The Gothic Imagination

Also by Linda Bayer-Berenbaum:

Renaissance Art

The Gothic Imagination

Expansion in Gothic Literature and Art

Linda Bayer-Berenbaum

Rutherford · Madison · Teaneck
Fairleigh Dickinson University Press

London and Toronto: Associated University Presses

© 1982 by Linda Bayer-Berenbaum

Associated University Presses
440 Forsgate Drive
Cranbury, NJ 08512

Associated University Presses
25 Sicilian Avenue
London WC1A 2QH, England

Associated University Presses
2133 Royal Windsor Drive
Unit 1
Mississauga, Ontario
Canada L5J 1K5

SECOND PRINTING

Library of Congress Cataloging in Publication Data

Bayer-Berenbaum, Linda, 1948-
 The Gothic imagination.

 Bibliography: p.
 Includes index.
 1. Horror tales, English—History and criticism.
2. Gothic revival (Literature) 3. Gothic revival (Art)
I. Title
PR830.T3B39 823'.0872'09 80-67035
ISBN 0-8386-3068-5 AACR2

Printed in the United States of America

Dedicated to Michael

Contents

Acknowledgments

Upon completion of a book, as at the birth of a child, a flood of gratitude and memory inundates the author, who recalls all those whose writing and teaching, insights and suggestions, affirmations and criticisms contributed in the broadest sense to the conception and refinement of a work. I cannot help but recall my own teachers: John Clayton of Boston University (now at the University of Massachusetts), William Barrett of New York University, Stanley Sultan of Clark University, and Richard Rubenstein of Florida State University, whose thoughts and writings engaged me and with whom I have been in constant dialogue far beyond the time of our actual encounters. I often realize as I confront my own students that though professors relinquish their students every few years for others, a few professors stay on within the student as lifelong intellectual companions.

I owe a particular debt of gratitude to professors Charles Blinderman and J. Russell Reaver, who guided and encouraged me on earlier versions of this work and whose intimate knowledge of the Gothic and the occult, in the first case, and of psychological and structural concepts in the second, helped me to view the material from new perspectives. For their direction and comments with respect to content and methodology and above all for the freedom of thought they fostered, I am deeply grateful.

I think of my colleagues who have read and reacted to this work. My thanks to Ziva Maisels, Chairman of the Art

[9]

Department at the Hebrew University, for her suggestions on expanding my approach to Gothic art, and to Philip Hallie of the Philosophy Department at Wesleyan University for our discussions of *Melmoth the Wanderer* and the nature of evil. My deepest appreciation is extended to Gloria Stern for her advice and help in placing this manuscript. When I was out of the country for a prolonged period of time, I entrusted my book to her care, and I could not have left it in better hands.

Ginger Harris must surely be mentioned for her patience and skill in deciphering the cryptic course of my handwritten manuscript and for typing this work in its entirety. Lillian Bayer, my mother, proofread the text meticulously, and I am grateful to her now as in the past for her critical suppression of my creative approach to spelling.

Above all, I wish to thank my husband, Michael, for his example and support. His even keel has often weathered stormy seas with a sense of calm and determination. He has courageously rejected a tradition that would have me as an aspect of himself in favor of real intimacy, struggle, and respect. In my work as in his we have grown together.

Finally, I thank our daughter, Ilana, and our son, Lev, for the joy and beauty of their distracting presence.

Introduction

Ten years ago, when I began my study of Gothicism, the "Gothic renaissance" was just beginning. Although a few Gothic phenomena had begun to surface (the movie *Rosemary's Baby* had appeared, for example), the term *Gothicism* and all it designated remained unknown to the general public and to many academics as well. Even in the best universities with the most extensive departments of English, a course in Gothic literature was extremely rare. When I told friends I was doing research on Gothicism, few were familiar with the literary genre or could recall a single title of a Gothic novel. Most smiled politely and, in an attempt to mask their ignorance, responded, "Oh, it must be very technical."

Today, ten years later, the term *Gothic* has become a household word. In a discount department store, of all places, I recently noticed that in the book department beside the sections marked "Cooking" and "Nonfiction" an entire aisle was labeled "Gothics" and contained over a hundred selections. The film *The Exorcist*, a classic Gothic work, drew larger crowds than any previous movie, and the book sold over seven million copies. During these last ten years we have experienced a general revival of the occult, of astrology, of the science-fiction brand of the Gothic, and even of Classical Gothicism. Now one can hardly find a college in the country that does not offer courses in Gothic literature. Gothicism has gained a sense of academic respectability as it has grown in popularity.

I myself backed into a study of the nineteenth-century Gothic novel (and thirteenth-century Gothic art) after first detecting more and more Gothic signs around me. A peculiar glorification of violence beginning in the late sixties smacked of the Gothic. The radical *Weathermen* group raved about "the quickening of the senses" that accompanied violent confrontation, one member reporting that he felt "fully alive" for the first time in his life when attacking a helpless victim. Similar descriptions of more and less serious encounters with the mind-expanding properties of LSD, with transcendental meditation, or with astral projection also partook of the Gothic, as did the more obvious interest in séances, tarot cards, and extrasensory perception. Much popular literature and art took a Gothic twist, and traditional Gothic literature enjoyed a renewal of interest.

The Gothic revival, whether in popular culture or in older Gothic art forms, is not merely a whimsical fad unrelated to the tenor of our times, to the modern predicament. The return of the Gothic novel is not simply a romantic nostalgia for times gone by—for old creaking castles or Victorian mansions—but is an expression of some of the most exciting and most disturbing aspects of modern existence. In order to fathom the inherently modern appeal of Gothicism, we must look beneath the spiderwebs and trap doors to the essence of the Gothic orientation. Gothicism is not merely a style; it entails a philosophy, and as a philosophy it speaks to the twentieth century.

The Gothic philosophy deals with the nature of transcendence, a transcendence that at first appears to be most alien to modern thinking. Scientific rationalism, after all, has sought to banish the fantastic by explaining it physically, sociologically, and psychologically. What has been repressed, however, is attractive and hence, like pornography, thrives on censorship. In this sense the Gothic revival can be likened to a variety of religious cults that have grown in

popularity, be they Christian fundamentalist, Hari-Krishna, the Sufis, or, most recently, the Moonies. Unlike these movements, though, Gothicism asserts that transcendence is primarily evil. This central confrontation with evil—this sense of impending doom—strikes a responsive chord today, for beneath the obvious benefits of technology lurk the threats of depersonalization and, indeed, of global annihilation. The popularity of triumphant religious cults may represent a desperate desire to deny or escape the destructive aspects of modernity that Gothicism reflects.

Only within the last few years have we fully begun to face the destructive, demonic nature of the Second World War. After nearly twenty years of stunned silence, the study of the Holocaust and Nazism is receiving renewed attention. It is no accident that Peter Blatty begins his Gothic work *The Exorcist* with apparently unrelated accounts of modern torture and with the names "Dachau, Auschwitz, Buchenwald," even though the concentration camps and his introduction do not ostensibly bear on the plot of the novel in any way. Blatty is suggesting that his imaginary expression of the demonic is related to our historical experience of evil. Both modern history and psychology have left us little doubt as to "what evil lurks in the minds of men." The study of evil has now come of age as the potential for evil has magnified, and Gothicism is the imaginative counterpart to this historical realization. Gothicism is the art of the deadly.

While science may repress transcendence, technology actualizes it. Technology increases and extends our powers and separates us from our effects. (The flyer pilot dropping bombs from his plane need never directly see the results of his actions.) Technology can both distance us or magically bring us together over vast distances. Consider how a telephone makes possible "mental telepathy" when we speak instantaneously to a person in another country. The average telephoner understands little about how the phone

works. He operates with the unknown. In reality, then, modern man does not believe less than his predecessors; he believes more. He accepts his science on faith. As science and technology become increasingly complex, people must cling to partial, seemingly preposterous explanations. We are told that solid objects are really swirling particles, for example, or that time slows down when speed increases. For the overwhelming majority, such inventions as television are all but miracles, and although the average persons can prattle a little about electromagnetic waves, he really does not understand how the ball kicked in Dallas suddenly appears on the screen in New York, how tape recorders capture voices, or how planes and satellites fly through space. Most people are surrounded by a technology they can neither understand nor personally create or control. The distance from radio waves to mental telepathy is really not very far for the layman. Science and technology are as good as magic to most of us. Thus our tolerance for the incredible is steadily increasing, not decreasing, and Gothicism is the art of the incredible.

Furthermore, technology has effected a general expansion and intensification of consciousness consistent with the Gothic sensibility. Marshall McLuhan has written of the media as an extension of the central nervous system—through our technology we can now virtually see and hear around the world and beyond. We have magnified the sound of our voices as well as the strength of our hands. It is therefore no wonder that we seek for and create greater intensity and immediacy in our art—not only louder, amplified music and the saturated colors of acrylics but combined, multimedia art forms as well. Psychedelic art and the drug culture that spawned it were motivated by this search for intensified consciousness, and although that movement has largely subsided, its thought patterns and vocabulary have been absorbed by the general culture. (The theme

song for the children's show *The Electric Company* begins, "We want to turn you on," and other phrases implying intensification or expansion coined by the drug culture, such as "getting high," have become part of our vocabulary.) Psychedelics were just beginning to wane when Gothicism came into fashion, and the affinity between the two lies precisely in this expansion and intensification of consciousness. However, psychedelics relied too heavily on technical aids–on electronic instruments, for example–on form rather than content. Gothicism represented a more substantial artistic tradition that spoke to the modern condition.

The augmentation of ability that science has provided has brought us to the point where yesterday's Gothic nightmares now see the light of day. The story of Frankenstein, of a monster formed in a laboratory from human parts, no longer belongs to the remote realm of fantasy; through cellular fusion and gene cloning, bizarre and terrible creations are now being implemented, and the control of experimentation with human mutations, with new and deadly bacteria, and with all sorts of creatures developed by chromosomal tampering is an abiding concern for the scientific community, for governmental agencies, and ultimately for all humanity. Just this year an ethical review board on biohazards was presented with a case concerning a being that was half human and half hamster, a scientist requesting that he be able to keep the hamster-person alive until it was ready to be born from its artificial womb rather than kill it prematurely in its embryonic state. The military establishment in this country and others is conducting similar experiments (presumably to produce the perfect spy with the brain of a human and the body of a dog?). We have recently heard voiced the fear of a pandemic, a fatal plague of global proportions now possible as a by-product of our own medical accomplishments. When so many researchers

have access to laboratories or have facilities in their homes where unsupervised procedures can be conducted, irresponsibility or accident could produce unpredictable manifestations. As we have seen with respect to nuclear reactors, even the products of our best intentions may get out of hand and threaten us with catastrophe. The stakes have been increased by the greater sophistication of our technology, its greater scope and power. We now stand closer than ever before to a fulfillment of the Gothic fear of monstrous devastation, of the violation of nature, or of an altered, maimed existence.

A social and psychological analysis of the current Gothic revival inevitably leads to a deeper understanding of modernity as well as to the essence of the Gothic art form. An intensification of consciousness, an expansion of reality, and a confrontation with evil are the central ingredients in both the Gothic and modern endeavors.

The Gothic Imagination

[1]
Literary Gothicism

THE word *Gothic* originally referred to the Northern tribes that invaded Europe during the fourth, fifth, and sixth centuries. The term was later applied by Renaissance critics to the style of architecture that flourished in the thirteenth century, because these critics thought that the style had originated with the Goths. This architecture was held in low esteem during the Renaissance, and the word *Gothic* therefore developed pejorative connotations suggesting the uncouth, ugly, barbaric, or archaic. It implied the vast and the gloomy, and subsequently denoted anything medieval. Later the word indicated any period in history before the middle or even the end of the seventeenth century. *Gothic* loosely referred to anything old-fashioned or out of date. The ruins of Gothic cathedrals and castles were naturally termed *Gothic*, and soon any ruins—the process of decay itself—became associated with the Gothic as did wild landscapes and other mixtures of sublimity and terror.

The Gothic movement in literature began in England during the second quarter of the eighteenth century, and because it encompassed a general interest in the past, in archaeology, antiques, and ruins, particularly those of the Middle Ages, the label *Gothic* seemed appropriate. This Gothic revival was a reaction against earlier eighteenth-century order and formality, and it gleaned its inspiration

from medieval Romantic literature. A changing attitude toward nature and feeling evolved; wildness and boldness came into vogue. The Romantic qualities of yearning, aspiration, mystery, and wonder nourished the roots of the Gothic movement. Sensualism, sensationalism, and then sadism and satanism were nurtured in an orgy of emotion. The child of Romanticism, the Gothic movement in literature exaggerated and intensified its parent's nature.

Horace Walpole, Ann Radcliffe, Matthew Lewis, and Charles Robert Maturin, as well as hundreds of less capable Gothic writers, established the conventions for the Gothic novel, which were later drawn upon by Mary Shelley, Jane Austen, Emily Brontë, Edgar Allan Poe, Bram Stoker, Charles Brockden Brown, William Godwin, Thomas Love Peacock, William Beckford, Edward Bulwer-Lytton, and Robert Louis Stevenson, to name only a few. The works of these authors differ significantly; critics have even identified different schools of Gothic literature—a Gothic historical school, a school of terror, and a school of horror, for example. Nonetheless, a basic orientation to reality is apparent in all Gothic works. The standard Gothic paraphernalia (haunted castles, creaking staircases, vampire bats, and secret passageways) are only the trappings that may or may not be present. More substantial characteristics reappear from work to work, such as recurrent character types, plot patterns, and themes, as well as common psychological and sexual attitudes, similar treatments of fear, pain, compulsion, and disgust, and comparable views of religion and politics. Although the standard conventions for the Gothic novel were developed during the eighteenth and nineteenth centuries, Gothicism itself is not restricted to a single time and culture or even to a single style of writing. The origins of the Gothic sensibility predate the eighteenth century, and works that are essentially Gothic are being produced today.

The traditional Gothic paraphernalia, now familiar to
any school child, was established in Walpole's *The Castle of
Otranto* and Radcliffe's *The Mysteries of Udolpho,* the pro-
totypes of the early Gothic novel. The graveyard and the
convent, the moats and drawbridges, dungeons, towers,
mysterious trap doors and corridors, rusty hinges, flicker-
ing candles, burial vaults, birthmarks, tolling bells, hidden
manuscripts, twilight, ancestral curses–these became the
trademarks of the early Gothic novel. They prepare the
reader for later apparitions, reducing his incredulity and
encouraging a suspension of disbelief. These trademarks
are symptoms of underlying Gothic assumptions. They
symbolically echo the dimensions of the Gothic reality, serv-
ing as rituals that invoke that reality. However, beneath the
Gothic gimmicks, the essential tenet is an expansion of
consciousness and reality that is basic to every aspect of the
Gothic, from setting to metaphysical claims.

Gothicism insists that what is customarily hallowed as real
by society and its language is but a small portion of a greater
reality of monstrous proportion and immeasurable power.
The peculiarly *Gothic* quality of this extended reality is its
immanence, its integral, inescapable connection to the
world around us. The spirit does not dwell in another
world; it has invaded an ordinary chair, a mirror, or a
picture. The soul has not gone to heaven; the ghost lingers
among the living. Furthermore, the perception of the
expanded reality involves an expansion of consciousness.
Sometimes external occurrences precipitate this height-
ened concentration, as when a person is so shocked by what
he sees that he enters a state of complete awareness; at other
times an initial heightened consciousness makes possible the
detection of an external reality–such as the hovering
presence of some strange apparition. Through heightened
sensitivity and refined perception, the Gothic mind
encounters a greater intensity or reacts to it.

The Gothic setting first introduces the expanded domain by insinuating that reality may be higher and deeper and more tangled than we ordinarily think. Persistent contrasts illustrate this greater scope. The Gothic landscape plunges from extreme to extreme; from the height of an airy bell tower to the depth of a dungeon vault; from the mass of heavy stone walls to the delicate, illusive spiderweb; from utter darkness to a candle's flicker; or from hollow silence to a high-pitched squeak. Even modern Gothic novels that have abandoned these clichés maintain extreme contrast. The shrill scream still manages to shatter silence, lightning breaks the darkness, and a sudden chill of wind stirs a hot and heavy night. In Bram Stoker's *Dracula*, for instance, Dracula himself first appears as gleaming bright eyes and white teeth against the black of his garments and the night. Later he is described as a long, black figure leaning over Lucy's frail, white form. Dracula's dark castle cuts a jagged line against the moonlight, and in the daytime a drab haziness is pierced by brilliant green grass and glowing silver tree trunks. When the full-moon appears, it is accompanied by black, driving clouds, and a black bat periodically flits across its brightness. The terrible storms recorded in Nina's newspaper clipping erupts from a calm sea without warning; Renfield is violent all day and quiet all night; the men leaving the burial chamber are particularly conscious of that moment when the pure night air replaces the pungent stuffiness of the vault—such examples are virtually endless. These contrasts are included in Gothic literature because they magnify reality; between the greatest extremes lies the greatest breadth. The constant presence of polar opposites prevents us from mistaking any single dimension for the whole, and with respect to density, as opposed to scope, the mind is unable to tolerate extremes for very long. We either avoid, or forget, the unbearable or become accustomed to it, yet persistent contrast discourages adjustment, because in

the clash between two states we can adjust to neither, and thus any dulling of the senses is averted. Whether by superficial color contrasts or more basic emotional and thematic juxtapositions, the Gothic novel sustains unmitigated sensitivity.

The castle (or the convent) in Gothic literature is a good study in contrast. Usually situated in a wild forest or uninhabited mountain range where the sky is unsettled and the wind howling, the calm and the stable are set amid the wild and dynamic. God's creation is pitted against man's in the clash between nature and architecture. Internally, the castle accentuates a contrast in power for its inhabitants by fortifying the power of its owner and diminishing that of his victim. By preventing the prisoner from escaping or receiving aid, the castle renders the victim more passive in comparison to the villain as does the storm that often rages outside, discouraging flight or rescue.

Contrast in Gothic literature is not limited to setting but is echoed in characterization and theme. "The Gothic novel presents no restful shades of gray: the characters are mostly endowed with either somber, diabolic villainy or pure, angelic virtue."[1] There are the villains—the interfering, brutal fathers, the officials of the Inquisition, the sadistic monks and abbots, or the ugly, monstrous foreigners; there are the victims—the helpless, innocent virgins or the naive and sensitive youths; and there are the heroes—the dauntless, gallant, handsome knights, the courageous, insistent saviors. If the victim is of noble birth, the hero is frequently a peasant. The scatterbrained, chattering domestic servant provides comic relief, but she is also important as a counterimage for the deep, intelligent, serious heroine or for any of the supermen who inhabit the Gothic world. The stereotyping of these characters is the price that must be paid for the desired contrast, yet the Gothic sensibility judges the accompanying gain in intensity well worth the loss of

realistic portraiture. Many of these characters' virtues and vices, as well as many general themes in the Gothic novel, are not important in their own right but only as antithetical tendencies. Idealized femininity, for example, is extremely common in the Gothic novel and is usually more functional as a backdrop for cruelty than as a convincing description of behavior. Gushing sentimentality is set beside brutality, each to highlight the other. The restoration of nobility and hereditary rights is likewise more striking when the restored noble was initially a pauper, and savagery and revenge, violence and hate are constantly set in the context of chivalry and honor, suffering and courage, love and loyalty. The principle of contrast that dilates the mind is here, as elsewhere, more important than content.

Besides contrasting extremes, twisted convolutions in Gothic settings also extend the conception of reality. The devious and elusive nature of life is reflected in the winding staircases and underground tunnels that challenge the restrictions of three-dimensional space. In their tortuous windings, they baffle our sense of direction and threaten to lead us out of the known and into the depths of another dimension. The lack of simple forms and clear direction can also be detected in plot progression. A long, complicated story line can more easily sustain a constant level of anticipation than can a direct exposition and resolution, and therefore the Gothic novel tends to replace the climax of the novel with the constant presence of the supernatural or with ever-developing contingencies. The Gothic writer is reluctant to sacrifice any intensity to rising or falling action before or after a climax, so that when the climax is not eliminated altogether, it is often postponed until the very end of the novel. The absence of clear boundaries and distinctions in setting is compounded by haze and darkness, permitting infinite possibilities that would be dispelled by clear perception.

In time some of the contrasts became overused and, like many of the ritual Gothic trademarks, such as the castle, they lost their power through familiarity. The medieval tone began to fade in Matthew Lewis's *The Monk* and William Godwin's *Caleb Williams,* and finally vanished altogether in such works as Mary Shelley's *Frankenstein* and Oscar Wilde's *The Picture of Dorian Grey.* Although the traditional hallmarks of the Gothic had withered, the fear and thrill of a greater reality remained.

Gothic literature continued to portray all states of mind that intensify normal thought or perception. Dream states, drug states, and states of intoxication have always been prevalent in the Gothic novel because repressed thoughts can surface in them; under their influence inhibitions are minimized, and thus the scope of consciousness is widened. Gothic novelists are particularly fond of hypnotic trances, telepathic communications, visionary experiences, and extrasensory perceptions, for these reveal the secret recesses of the mind or powers of increased mental transmission and reception. Hallucinations augment mental images to the point of visual perception, and visions involving future occurrences challenge the confines of space and time.

Sleep, the most readily available alternative to ordinary, waking thought processes, receives considerable attention in Gothic novels, both within the stories themselves and as sources for the authors' inspiration. Horace Walpole wrote of *The Castle of Otranto:*

> Shall I even confess to you what was the origin of this romance? I waked one morning in the beginning of last June from a dream, of which all I could recover was, that I had thought myself in an ancient castle (a very natural dream for a head filled like mine with Gothic story) and that on the uppermost bannister of a great staircase I saw a gigantic hand in armour. [2]

Mary Shelley similarly writes that her book *Frankenstein* was based on a dream.[3] Within the Gothic novel, characters frequently question whether or not they are awake or merely dreaming, often describing strange states of awareness between sleep and wakefulness where neither the reality of the dream nor that of wakefulness can dispel the other so that both persist in an expanded, double encounter. Deprivation of sleep is also investigated by Gothic writers; for example, Count Dracula meets with Jonathan Harker only at night, and Harker's lack of sleep and changed sleeping patterns alter his perceptions. Gothic writers exploit night-consciousness in general, highlighting changes in temperament from morning to evening related to drowsiness and fatigue or even to the gravity of the moon and other variables. In the state of night-consciousness, as portrayed in Gothicism, a person is more susceptible to the power of suggestion, less analytical or rational, less strictly controlled; the defense mechanisms of the psyche become weary and less effective.

Gothic scenes never seem complete without their share of crumbling architectural remains, rotting old houses, ancient relics, and even decrepit, senile people. This attraction to ruins might initially appear to oppose the notion of an expanded reality by emphasizing a temporal, physical world in decay, yet considered from another angle, ruins indicate the limitless power of nature over human creation. Death and sickness lead us to acknowledge the extent of the forces that control us, and in the face of death we recognize the omnipotence of time and try to confront our own annihilation. The concept of self-extinction stretches consciousness; we probe the limits of our minds with fear, with caution, and yet with a certain thrill. We are attracted to that great beyond. (Freud connected *thanatos*, his term for the attraction to death, with a repetition compulsion,[4] which is particularly interesting in that unvaried repetition is a key element in Gothic imagery and word usage.) The decay of a building, so

much more solid and permanent than human flesh, consciously or subconsciously raises the question of death. In her book *Gaston de Blondeville,* Ann Radcliffe describes the remains of an old buildings in terms of "the nothingness and brevity of life."

> Those walls seemed to say—Generations have beheld us and passed away, as you now behold us and shall pass away. They have thought of the generations before their time, as you now think of them, and as future ones shall think of you. The voices, that revelled beneath us ... have passed from this scene forever; yet we remain, the specters of departed years, and shall remain, feeble as we are, when you, who now gaze upon us, shall have ceased to be in this world. [5]

When the walls that outlast generations crumble, the powers of time appear even more awesome. In the face of decaying material, we sense the eternal forces of destruction, and the eternity of time is contrasted by the temporality of matter. Diderot expressed this notion when he spoke of the ruins he painted:

> You don't know why ruins give such pleasure. I will tell you. Everything vanishes, everything perishes, everything passes away; time goes on and on. ... How old, how very old the world is. I walk between two eternities....What is my life as compared to this crumbling stone? [6]

The Gothic fascination with death and decay involves an admiration for power at the expense of beauty. In his discussion of Gothicism in the plastic arts, Charles Moore stresses this preference for power, [7] and similarly in Gothic literature, the force of nature, of evil, of the supernatural, or of love is elaborated, demonstrating an awe of the powerful in any form. Those factors which conquer life and disintegrate matter become the object of great admiration.

Another aspect of the Gothic attraction to ruins relates to irregularity. William Shenstone, an eighteenth-century poet, wrote:

> Ruinated structures appear to derive their power of pleasing from the irregularity of surface which is variety; and the latitude they afford the imagination to conceive an enlargement of their dimensions, or to recollect any events, or circumstances appertaining to their pristine grandeur and solemnity.[8]

The attraction to irregularity stems from an attraction to the incomplete; what is not whole, not self-contained or balanced, is more prone to motion and change, to the dynamism that characterizes Gothic art forms. When one views the partiality of ruins, the enlargement that the imagination provides in its attempt to reconstruct the building's dimensions can surpass the original measurements. The very process of imaginative enlargement is at the heart of the Gothic expansion.

Seen from another perspective, the attraction to ruin and decay expresses the general Gothic abhorrence of restriction, in this case the aesthetic restriction to health or beauty, just as Gothicism resists sexual, political, or religious taboos. A fascination with disease and decomposition represents a liberation from the confines of beauty. The weak, the rotten, and the offensive are hallowed by the Gothic mind in and of themselves, and are then set in contrast to strength, vigor, and beauty.

The grotesque aspects of Gothicism are evident in the caricatures that evolved from fifteenth-century ornamentation and in the repulsive characters and gruesome scenes from Gothic literature. A predilection for deformity is unmistakable. Often Gothic villains have huge noses or eyes, elongated foreheads, growths or moles, enormous hands or teeth, scars, cleft palates, or hunched backs. Both

caricatures and grotesques are created through exaggeration rather than by a complete departure from normality. The exaggeration of just one aspect of the beautiful can produce the hideous, and thus the Gothic intensification without regard for beauty and proportion is also operative here.

When distortion is not involved, the grotesque can be simply achieved through unusual combinations of the normal or even the beautiful, through an unexpected fusion of different realms. This aspect of the grotesque, like other aspects of the Gothic, can be described as particularly nontranscendent, for the strange creatures that appear are not totally other—they are not complete departures from the known but unusual amalgamations of the ordinary. When we dissect the purely ugly, we find that its parts are ugly, but when we dissect the grotesque, we may find that its parts are pleasing. We are left to wonder what strange power has caused the familiar to become so unfamiliar, so terrible.

The grotesque can be further understood as a demonstration of underlying chaos. "Instead of suggesting the fluidum of eternal love, the grotesque now opens the view into a chaos that is both horrible and ridiculous."[9] The grotesque insults our need for order, for classification, matching, and grouping; it violates a sense of appropriate categories. The resulting disorientation reinforces an ultimate vision of disorder at the root of the Gothic endeavor, for the rejection of all restrictions must necessarily produce chaos, a chaos similarly implied in the celebration of ruins. A certain revolt against materialism and the tyranny of the physical world is involved here, as it is whenever spirits defy matter. In its most basic implication, the Gothic quest is for the random, the wild, and the unbounded.

Much of Gothic literature deals with pain and torture,

with sadism and masochism described in bloody, gruesome detail. Matthew Lewis's description of the death of the monk is not atypical in its gory explicitness.

> The sun now rose above the horizon; its scorching beams darted full upon the head of the expiring sinner. Myriads of insects were called forth by the warmth; they drank the blood which trickled from Ambrosio's wounds; he had no power to drive them from him. ... The eagles of the rock tore his flesh piece-meal, and dug out his eyeballs with their crooked beaks ... six miserable days did the villain languish. [10]

Agony, or the attempt to imagine it, is a very effective technique for intensifying perception; in that the suffering person desperately desires relief, pain is an instant cure for apathy and insensitivity, passivity and moderation, the enemies of the Gothic spirit. Some psychologists have defined pain itself as an intensification of sensation: " ... unpleasure corresponds to an increase in the quantity of excitation and pleasure to a diminution." [11] When applied to the Gothic aim, this theory would insure that suffering became a necessary aspect of the Gothic endeavor. The Gothic sensibility applauds Byron's statement that "the great object of life is sensation, to feel that we exist, even though in pain."

The contemplation of the possible degrees of pain, apart from any related anxiety, stimulates curiosity and may draw people to witness or even suffer cruelty; a paradoxical pleasure in pain can motivate torture, affecting the victim as well as the villain, as portrayed in a great many Gothic novels where the victim is often paralyzed by his attraction to his tormenter. As a result of his fascination, the victim becomes even more passive, thus increasing the contrast between victim and villain. Both are drawn to pain and torture as is the reader of torture tales. At the very least it

staggers the imagination to project the pain of a limb ampu-
tation from the relatively small cuts and burns that most
people experience. In this sense the reader stretches his
mind to imagine great pain and admits into consciousness
the bestial tendencies he usually rejects.

The question of sadomasochism in Gothic literature goes
even deeper, though. On one hand, the Gothic thrill
depends on a heightening of sensual and sexual pleasure,
but on the other hand, Gothicism does not repress the
countervailing attraction to death. Gothic literature is
characterized by an intricate interplay between eros and
thanatos, to which the confrontation with pain serves as
catalyst. Since Gothicism shuns harmony and accord, the
violent struggle between life and death is the central drama.

Death is attractive in Gothicism for the absence of limita-
tion it implies, for its absolute finality, for the mystery of its
void, and for its primeval chaos. The attraction to death is
apparent not only in the predominance of the death theme
but also in the Gothic need to prove life forces, to test them.
A strong attraction to quiescence is presupposed when a
Gothic character confronts disaster in order to overcome
apathy and thrillingly feel a resurgence of life. The Gothic
character confronts danger out of an initial attraction to
death.

Despite the lure of death, that black-draped phantom in
his menacing chariot does evoke a sense of terror. Terror is
a primary Gothic ingredient not only because it is a reaction
to threat but also because of its own physiological quality.
The terrified person, and the reader by identification,
becomes suddenly alert. He notices how chilly the room has
become or how dark the night has grown. He may sense the
pulsation of blood through the tips of his fingers or notice a
piercing smell of sulphur in the air. In terror a person feels
powerfully present, starkly alive. The words *terror* and *horror*
are often used erroneously as interchangeable reactions to

frightening experiences. Both involve fear and repulsion, but terror is more immediate, more emotional, and less intellectual. You may be horrified by what your friend tells you but terrified by what you yourself see. Ann Radcliffe felt that terror and horror were "so far opposite, that the first expands the soul, and awakens the faculties to a higher degree of life," while "the other contracts, freezes, and nearly annihilates."[12] Terror is more potent and stimulating and thus the more Gothic emotion.

Terror in Gothic literature is sometimes caused by human or natural actions, but more often the formidable agent is in some sense supernatural. In his book *The Supernatural in Fiction*, Peter Penzoldt explains the supernatural as a cause, dismissing its independent importance for Gothic writers. "The preternatural was merely another item in their astonishingly rich repertoire of melodramatic effects and was hardly more important than crime, guilt, lust, or passion."[13] Certainly, all these emotions are intense, lust and passion sexually and emotionally, crime socially, and guilt psychologically, and like them the supernatural is extreme (an extreme extension of consciousness to the point of independence from an individual mind), but the supernatural is more important—here thought is not merely immoderate; it actually becomes omnipotent. The ability to think has been projected beyond the human mind and then given the capacity to alter the physical world, to materialize objects at will, instantaneously, miraculously. The supernatural therefore represents the ultimate expansion of consciousness.

The Gothic supernatural appears particularly real, disturbing, and uncanny, because it is so close; it permeates the world around us, looming fantastic and immediate. By comparison the religious type of transcendent supernatural is somewhat remote, projecting a numinous realm that is more otherwordly—heavenly rather than earthly, spiritual

rather than physical, sacred rather than profane. The Gothic mentality seeks to obliterate all such distinctions to render the supernatural greater and nearer, and thus it avoids the make-believe aura of the fairy tale. Particularly in the modern horror stories where ancient castles have disappeared, the Gothic writer clothes his tale in the fabric of the familiar. The aim of the supernatural in Gothic literature is to become as natural as possible, an extension of nature; therefore, in the Gothic context, a more fitting term might be *transnatural.*

The supernatural in Gothicism involves the materialization of the spiritual, such as when a ghost takes form and moves a chair or when a spoken formula makes a dog turn into a fly, but also the spiritualization of the material. Magic mirrors, enchanted wands, and mysterious potions are all material objects that have taken on spiritual powers. The rejection of physical restrictions can also be interpreted as a spiritualization of the material. Ghosts and vampires are rejections of time in that they live on indefinitely, and wraiths (apparitions of living people) are in the same sense rejections of temporal and spatial limitation. A number of Gothic creatures, such as the ghoul, are neither male nor female yet somehow both, defying sexual definition. The ghoul feeds on corpses, bringing death into life, as the vampire (which is dead) feeds on life blood. The recurrent Gothic theme of the living dead or the dead alive strains the distinction between (and thus the limitations of) life and death in a manner parallel to the way the physical and spiritual realms overlap. In both cases a greater inclusion is circumscribed by the fusion of opposite categories.

Gothicism and Christianity have had a strong and intimate relationship marked by both kinship and enmity. In its belief in God and life after death, in its miracles, mystical visions, and transubstantiation, Christianity resembles Gothicism, and Gothicism like Christianity pays homage to

the holy. (It does not restrict itself to the horrible.) The Gothic imagination, like the religious imagination, reverently acknowledges awesome and terrible spiritual forces operative in the world. This affinity has led Gothic writers to borrow and then modify religious symbols and archetypes. The entire cult of witchcraft upon which Gothic literature so generously draws is steeped in modified religious symbols. The location of the witches' sabbat is marked by an inverted cross, for example, and holy water and candles to the devil are essential sacraments in the Black Mass. Satan himself is the ape of God, adored by his worshipers with genuflections and prostrations; the ritual dances of witches mime the ceremonial church dances that were practiced as late as the seventeenth century; and the climax of the witches' sabbat is the reception of the sacrifice at the altar as it is in the church service. In addition to outright adaptations of religious symbols, Gothic literature also concentrates upon the lives of religious people and the peculiarities of clerical institutions. Churches, convents, cloisters, abbots, friars, monks, and nuns constantly reappear, and criminal clergy are particular favorites, such as homosexual priests who become killers, or nuns who discard their vows and then break laws. When transgression or perversion is coupled with religion, both the upright and the fallen are encompassed—the greatest deviance, both positive and negative, being included. Religious models are not adopted simply because they are exotic; Gothicism recognizes the seeds of its own sensibilities in religious devotion and in all supernatural claims.

Except for the fact that Gothicism rids itself of moral prohibitions, the Gothic vision closely approximates religious affirmations. However, the religious censorship of forbidden thoughts and behavior is most repugnant to the Gothic endeavor, which accounts for the Gothic distortion of religious images. Gothicism ridicules the separation

between conventional reality and religious experience so crucial to Christianity, such as the distinction between the heavenly and the mortal or between the uplifted and the mundane, for Gothic terror is dependent upon a merger of the natural and the supernatural that undermines a sound, predictable reality. Furthermore, the Gothic temperament fundamentally objects to religious repression and displacement. Although Gothicism identifies with the quest for a greater metaphysical ground and the representation of deep desires and past deeds, it rejects the symbolic disguise that covers lustful or violent desires along with the ethical restraints of religion. Thus the symbolic wine that stands for blood in religious ritual returns to real blood in the Black Mass, and the eating of bread in place of flesh gives way to outright cannibalism. Religion seeks to moderate and control the greater experience theologically and morally, but in the absence of morality, Gothicism revels in intensity. The Gothic soul can admire the consistency of the sadist or the compulsion of the killer as it can the fervor of the fanatic. The devil can be worshiped as well as God.

The vampire is an interesting example of the Gothic distortion of a religious notion and the attempt to express overtly what Christianity had implied. In the vampire the spirit does not depart after death but remains with the body, preventing decay and forcing the deceased to return at night to the world of the living to suck blood as a form of sustenance. The living dead is a more immanent expression of the religious notion of life *after* death. The vampire is neither dead nor alive; he is both. Further, the vampire is neither human nor divine but a combination of the two; he is a spirit incarnate in life, not all-powerful yet not mortal. Like the saint or savior, he is all-suffering, a perverted Christ figure who offers the damnation of eternal life in this world rather than the salvation of eternal life in the next. Life after death has been transposed into a living death.

Vampires and werewolves are blatantly cannibalistic, and their violence has sexual overtones. The vampire sucks blood from his victims' necks in order to sustain himself. By comparison, *the followers* of Christ are sustained by symbolically consuming his blood and body. The lord's crucifixion is the Christians' salvation. The vampire, however, does not sacrifice himself to save others but sacrifices others for himself. The victims whose blood he drinks in turn become vampires. We see, then, that in Gothic garb self-serving, cannibalistic drives have been stripped of any communal redemptive justification, and bloodthirstiness is given unconditional reign.

The sexual component in the vampire's attack is evident in the descriptions of the attacks themselves and in the fact that most vampires strike at night in the victim's bed. An incestuous element is also clear since vampires often prey upon relatives—mothers, fathers, sisters, and brothers (in addition to husbands and wives). The vampire represents a repressed connection between sexuality and consumption that recalls the savagery of human sacrifice and pagan rites. These same sanguinary origins are represented in Christianity but are masked and reoriented so as to be purged rather than encouraged.

The origin of life and of human creation is a religious theme recast in Gothic literature where it unfolds on earth rather than in paradise with the absence of divine intervention. Frankenstein creates from animal and human parts the first man created by *man*. The monster actually sees himself as an Adam, but here he hates his creator for refusing him an Eve; "no Eve soothed my sorrows, nor shared my thoughts; I was alone. I remembered Adam's supplication to his creator."[14] The creature formed by Frankenstein is no passive supplicant, and indeed he seems justified in his condemnation of his lord. Mary Shelley sympathetically portrays the natural resentment of the

created toward the creator, a resentment that the Bible renounces. The religious questions of responsibility and retribution have here been wholly inserted into the human sphere; through the science that has given him the power of creation, man has grown to the dimensions of God.

Even though Gothicism may be considered religious insofar as it pursues the numinous, the repressed, and the all-powerful, it feels no less contempt for the forms of institutional religion. Gothic novels have been vehemently critical of the church. *Melmoth the Wanderer,* for example, exposes the unjustified torture conducted by the Inquisition in the name of God, and many Gothic novels allude to the illegitimate children born to monks and friars or cast the clergy in villainous roles. In one of his novels Matthew Lewis poked fun at edited versions of the Bible designed to protect the innocence of pure young girls. If we are not to accept that the Bible is lewd in some sections, then these church-approved deletions must be seen as ridiculous, as the over-zealous protest of "dirty little minds." The general antagonism between Gothicism and the church is aggravated by their mutual encroachment on religious territory, which accounts for the Gothic hostility toward Christian institutions.

The rise of the Gothic novel may itself be related to religious depravity in that Gothic practices provide a cathartic outlet for the sense of guilt that accompanies the decline of a strong religion, the horrors in the novel serving as a release for repressed fears. Gothic developments may suggest a new way of understanding and representing the expansion of consciousness that religion formerly confronted philosophically, liturgically, and ceremonially. In this light Gothicism can be understood as a decadent religion that continues to express the existence of the spiritual in the absence of belief in a benevolent God.

Insofar as religion is incredible, insofar as a person is hesitant to accept either an immanent or transcendent supernatural, he questions whether spirits or visions are not merely the product of his imagination. With this question Gothicism enters the haunt of the psychological. Mental and nervous disorders are excellent themes for Gothic stories because the illusions of the deranged often resemble traditional beliefs and superstitions. Gothicism suggests some psychological if not external veracity for superstition, some sanity in the insane. Madness is often portrayed as a highly developed sensitivity to a reality that normal people are too dull to perceive. In that superstitions are projections of fundamental psychological phenomena, Gothicism directs our attention to the internal world of the mind. The characters in Gothic novels are usually hyper-self-conscious. They scour the depths of their own intentions, questioning not only their actions and perceptions but their motivations and fantasies as well. They sometimes try to convince themselves that their encounters with the supernatural are merely products of their own mental disturbances. Many critics have noted the importance of psychological observation in Gothic literature. Devendra Varma goes so far as to claim that the Gothic novel was responsible for the development of the psychological novel, identifying Ann Radcliffe as "perhaps the first English novelist to dissect the human motives in a character."[15] Dorothy Scarborough insists that Mary Shelley introduced "something poignantly new in fiction" in her sensitive portrayal of Frankenstein's reaction to rejection and the interplay between hate and remorse.[16] Philip Hallie considers Charles Robert Maturin "as fine a psychological analyst as he is ingenious as a novelist."[17] When one thinks of psychology in Gothic literature, the link between guilt and crime or the mental response to torture is unforgettable in such works as William Godwin's *Caleb Williams*, and in the

writings of Edgar Allan Poe we see the psychological tale of
terror come of age. The effect of inner conflict or the
relationship between repression and explosion has always
been a central Gothic concern, as is the superconsciousness
that results from all mental probing.

Among the psychological states that Gothic novels inves-
tigate, extreme states are most abundant. In *The Monk*, for
example, we see strict piety suddenly change to sadism, with
little transition from repression to license, from monk to
murdering rapist. The forces of good and evil are at war,
and compromise is impossible; total victory and defeat are
the only alternatives. Here the juxtaposition of extremes is
psychologically drawn.

Mental disorders appeal to the Gothic temperament in
much the same way as do ruins. Insanity is a form of mental
deterioration, an internal ruin. Rather than the beauty of
order, balance, and proportion, Gothicism seeks the partial,
the drastic, or the extraordinary. The Gothic hero or villain,
be he artist or criminal, has refined or augmented one
aspect of himself to the point of inner tyranny. The intensity
of the psychotic and the power of his psychosis to devour all
other parts of the self fascinate the Gothic mind.

The instability of the deranged in the Gothic novel is
generally matched by the instability of the world outside the
self, so that strange, unpredictable happenings reinforce
the obsessions of the disturbed. At the same time that the
Gothic writer penetrates the world of the twisted mind, he
enlarges the outer world to include abnormal, bizarre
occurrences, simultaneously plunging inward and outward,
into the perceiver and beyond the perception, thereby
developing the dimensions of reality in both possible
directions.

Gothicism is no more inclined to accept sexual restric-
tion than psychological or aesthetic confinement. Sexual
excess functions physically as madness does psychologically;

one drive, one intention, becomes overpowering, all-consuming. Sexual perversions are important in Gothic literature for their intensity born of repression and for the expansion they provide in the range of sexual practice. Homosexuality, sodomy, incest, rape, or group copulations are inserted into ordinary experience in order to destroy the boundary line between the normal and the perverse, infecting the normal with the germ of the perverse so that all behavior becomes susceptible to possible perversion.

Rape in the Gothic novel is constantly introduced into unexpected surroundings. A maiden may be raped in her own bedroom with her mother in the next room, or in a church, or even in a burial vault, the unusual setting emphasizing the surprising or unnatural quality of the act while indicating that every setting can be a prospective scene for rape. The emphasis on rape also unmasks the socially repressed association of sexuality and aggression on the part of the male (as does the linking of sex and violence in vampire attacks). The Gothic fascination with power is surely evident here. Gothicism is attracted to all eruptions of unbridled sexuality, and the conquest involved in rape is often as significant as the sexual aspect of the act. The contrast between the triumphant evil of the rapist and the helpless innocence of the victim accentuates the magnitude of the villian's power.

Incest is another perversion prevalent in Gothic literature. The incestuous nature of an act is frequently discovered only after the fact, or it may arise as a by-product of other circumstances. A man will sleep with a woman and only later discover that she is his sister or mother or, as in the memorable scene in *The Castle of Otranto,* a father pursues his daughter-in-law only when his son cannot give him an heir. Abandoned babies and unknown identities are useful because they make accidental incest all the more possible, thus allowing perversion to creep into sexual relations that initially appear innocent.

Homosexuality is often depicted within the setting of unisexual convents or monasteries, which is one reason for their inclusion in Gothic literature (their religious nature being the other). Homosexual overtones are particularly pronounced in *The Monk,* where Rosario, a young initiate, is beloved by the monk. Sexual switches through disguises appear in many Gothic stories and often, as in this story, the true source of attraction is unclear. (Even after Rosario's identity is revealed, the reader suspects that Matilda was as much a disguised Rosario as Rosario a disguised Matilda.) The possibility of mistaken gender plants the potential for homosexuality in heterosexual relations. Lewis alludes to an underlying sexual element in religion (either homosexual or heterosexual, depending on the sex of the worshiper) when he portrays the monk's sexual attraction to a picture of the Virgin Mary. All sexual encounters become suspect, as do nonsexual ones, for there is no way to know what perversion may lurk behind appearances.

Much of the Gothic preoccupation with undertakers, tomb scenes, mummies, and unburied bodies is related to the suggestion of necrophilia (sexual relations with the dead). In necrophilia the contrast between aggression and passivity is most extreme, because the dead victim can in no way resist the violence of her attacker. The pathology of this disorder explains the practice as a substitutional outlet for certain types of sexual impotence.

The causes of necrophilia are essentially those of other sexual deviations. The sexual pattern operates as an ego-defense mechanism. Strong feelings of inadequacy make it difficult and sometimes impossible for the individual to carry out satisfactory sexual relations with other adults. The necrophiliac obtains a feeling of competency and power when he is having relationships with a corpse.[18]

A second psychological theory contends that necrophilia and coprophilia are normal components of the sexual instinct and thus "the instinct to spit or vomit at the sight of the disgusting things, in this case the corpse, is only the reaction of the unconscious desire to take these things into the mouth."[19] That contact with corpses, like feces, is considered dirty or nasty is here interpreted as an attempt to repress a natural attraction. In a less clinical discussion of this phenomenon, Erich Fromm speaks of a general necrophilic character type who is attracted to destruction of all kinds and not merely to corpses. He is a "lover of death" who sees the world in two categories: the powerful and the weak, the tyrant and the victim, the killer and the killed. The necrophilic character is so in love with both killers and death that they dominate even his sexual fantasies. Sexual intercourse may function like eating as a form of incorporation, and indeed necrophagia, the desire to eat a corpse, often accompanies the sexual act in the dreams of necrophiliacs.[20] The Gothic proclivities for death and decay, power, extremism, sharp contrasts, and repressed material are all implicated here in the necrophilic perversion.

Aberrant sexuality is frequently associated in Gothic literature with those who possess supernatural powers, such as witches and vampires. The witches' coven is held in the nude, and strange copulations with animals and sexual orgies may be involved. Such perversities contribute an additional dimension of shock to the initial, supernatural expansion.

In terms of politics, the Gothic novel has been continually associated with revolution and anarchy. The Marquis de Sade felt that Gothic literature was an outcome of the revolutionary upheavals in Europe.

The appearance of this novel was truly a literary event. It answered the need for strong emotions following great social upheavals, flattered sensualism with its voluptuous pictures and irreligion by the boldness with which it treated sacred things.[21]

André Breton, a spokesman for surrealism, also considered Gothicism a revolutionary art form produced by revolutionary sentiments, and Devendra Varma speaks of these same revolutionary tendencies in *The Gothic Flame:* "Interpreted in its social context, the Gothic novel is a subtle and complex aesthetic expression of the spirit of Europe in revolutionary ferment."[22] Varma goes on to relate the Gothic novel directly to the French Revolution, as did Michael Sadleir in his essay "The Northanger Novels."

The Gothic romance and the French symbolist movement were in their small way as much an expression of a deep subversive impulse as were the French Revolution itself and the grim gathering of forces for industrial war.[23]

Gothicism allies itself with revolutionary movements because it cannot tolerate any restriction of the individual, and thus Gothicism is not merely revolutionary but anarchistic in its sympathies. As all forms of order disintegrate, the Gothic mind is free to invade the realms of the socially forbidden. The danger to civilization that is likely to result does not deter the Gothic spirit, which is of course drawn to ruins and destruction anyway.

The antiestablishment tenor in Gothic literature, whether directed against the church, the Inquisition, or the government, champions individuals rather than institutions, and, furthermore, the restraints on the individual necessary to insure freedom are inconsistent with the Gothic bent toward license. Although Caleb Williams can protest, "I saw my whole species as ready in one mode or another, to be

made the instruments of the tyrant,"[24] we cannot forget that Gothicism admires individual tyrants. In the Gothic conflict between the tyrant and victim, the tyrant becomes the more important figure, his magnitude rather than the depreciation of the victim being emphasized. Fear rather than pity is the essential Gothic emotion, and the victim in the story, as well as the reader, is overawed by the conqueror. Society, culture, or government is not allowed to hamper unbridled individualism, as we see in the triumph of love over social convention lauded in Gothic novels. Clearly, the revolutionary sympathies in Gothicism do not really spring from any concern for the masses or for societal injustice, but from the expansion of personal experience. Gothicism does not want some to have less so that all can have more; it desires just the opposite. The Gothic mind at once admires the tyrant and supports the collapse of institutions.

The Gothic novel has drawn heavily upon Oriental material as a source for its stories and details. Herbert Read has distinguished among the Eastern Asiatic, Semitic, and monist (or pantheistic) approaches to reality, characterizing the Eastern Asiatic as intuitive or instictive, entailing a fear of the world and a need for liberation. He describes God's immanence in the Eastern approach, where human life nonetheless remains subordinate to the entire, incomprehensible process or being.[25] The Eastern approach, like the Gothic approach, depicts a supernatural that is a part of this world, and both share the immanence of a greater reality, a need for liberation, and the primacy of fear. It is therefore no wonder that many Gothic writers based their stories on Oriental tales or used Oriental motifs. Walpole read a great quantity of Eastern fairy tales, and the gigantic proportions in his apparition of Alphonso reflect an Oriental technique, as does the style of the beginning in *The Castle of Otranto:* "Manfred, Prince of Otranto, had one son and one daughter." The themes of cruel parenthood and one lovely

and one unlovely child are also originally Oriental. Walpole's use of gigantic, dismembered limbs is of Eastern origin, as is his disregard for the laws of probability. This Eastern propensity for extraordinary coincidence is prevalent in much Gothic literature, causing the reader to question whether the incidents described could possible be accidental or whether some mysterious force is secretly responsible. Many other Eastern borrowings could be cited, such as the scenes of Oriental splendor in Beckford's *Vathek,* and his use of genies, or even the outright incorporation of Oriental tales in Lewis's *The Monk.* The Gothic novel does not merely copy this Eastern material but combines it with Western conceptions, as can be seen in the Gothic combination of Eastern and Western ghost stories. Peter Penzoldt has compared Eastern and Western ghost tales, finding the former more supernatural and less scary. In the Eastern tale the ghosts and humans live side by side on an equal plane. The Gothic novel sought to utilize the immediacy of the Eastern ghost without losing the fear and respect connected with Western ghosts.

In analyzing the characteristics of Gothic literature, its images, preoccupations, alignments, sources, and influences, we see that we do not have here a random collection of propensities and tidbits. A single desire motivates the Gothic spirit and can be found at the root of all its peculiarities. The integrated assault of all these factors on the reader's soul accounts for the grip of the Gothic.

NOTES

1. Devendra P. Varma, *The Gothic Flame* (London: Arthur Baker Ltd., and Morrison and Gibb Ltd., 1957), p. 19.
2. Horace Walpole, "Letter to the Reverend William Cole," March 9, 1765 in *Horace Walpole's Correspondence,* vol. 1, W. S. Lewis (New Haven, Conn.: Yale University Press, 1937), p. 88.
3. Mary Shelley, *Frankenstein,* 3d ed. (New York: Bobbs-Merrill Company, Inc. 1974), intro., p. 118.

4. Sigmund Freud, *Beyond the Pleasure Principle*, trans. James Strachey (New York: Bantam Books, 1959), pp. 44-47.

5. Ann Radcliffe, *Gaston de Blondeville* (Philadelphia: H. C. Carey and I. Lea, 1826), 1:94.

6. Denis Diderot, *The Gothic Quest*, trans. Montague Summers (London: Fortune Press, 1938), p. 407.

7. Charles Herbert Moore, *The Development and Character of Gothic Architecture* (New York: MacMillan and Company, 1890), p. 87.

8. William Shenstone, *Essays on Men and Manners* (London: Jay Dodsley, 1780), p. 67.

9. Wolfgang Kayser, *The Grotesque in Art and Literature*, trans. Ulrich Weisstein (Blookington: Indiana University Press, 1963), p. 53.

10. Matthew Lewis, *The Monk* (New York: Grove Press, 1952), p. 45.

11. Freud, *Pleasure Principle*, p. 23.

12. A. D. McKillop, "Mrs. Radcliffe on the Supernatural in Poetry," *Journal of English and Germanic Philology* 31 (Urbana: University of Illinois Press, 1932): 357.

13. Peter Penzoldt, *The Supernatural in Fiction* (London: Peter Nevill, Ltd., 1952), p. 4.

14. Shelley, *Frankenstein*, p. 127.

15. Varma, *Gothic Flame*, p. 102.

16. Dorothy Scarborough, *The Supernatural in Modern English Fiction* (New York: G. P. Putnam's Sons, 1917), pp. 34-35.

17. Philip Hallie, *The Paradox of Cruelty* (Middletown, Conn.: Wesleyan University Press, 1969), p. 13.

18. Louise P. Thorpe, Barney Fatz, and Robert T. Lewis, *The Psychology of Abnormal Behavior: A Dynamic Approach* (New York: Ronald Press Company, 1961), p. 324.

19. Sandor Ferenczi, cited in William McDougall, *Outline of Abnormal Psychology* (New York: C. Scribner and Sons, 1926), pp. 163-64.

20. Erich Fromm, *The Heart of Man: Its Genius for Good and Evil* (New York: Harper and Row, 1964), p. 40.

21. Marquis de Sade, *Idée sur les Romans*, trans. Devendra P. Varma (Paris: E. Rouveyre, 1878), pp. 150-51.

22. Varma, *Gothic Flame*, p. 216.

23. Michael Sadleir, "The Northanger Novels, A Footnote to Jane Austin," *The English Association Pamphlet*, no. 68 (Oxford: The University Press, November 1927), p. 4.

24. William Godwin, *Caleb Williams* (New York: Holt, Rinehart and Winston, 1960), p. 321.

25. Herbert Read, *Art and Society* (reprint ed. New York: Schocken Books, 1970), p. 52.

[2]
The Relationship of Gothic Art
to Gothic Literature

SOME critics have alluded to a superficial correspondence between Gothic architecture and literature, such as an analogy between the winding, subterranean hallways and the secret recesses of the mind, but the relationship between the two art forms is far more fundamental. Gothicism in art, as in literature, expresses a coherent aesthetic and philosophic perspective. The different aspects of Gothic art can be explained in terms of this underlying principle, and direct parallels can be drawn between Gothic techniques in art and in literature.

The origins of Gothic architecture can be traced back to a particular style of ornamentation, and even in these early designs we detect the restless energy that characterizes Gothicism in both architecture and literature. In literature this energy fuels the compulsion that drives Gothic characters to pursue the objects of their curiosity or desires; it fosters a restlessness that leads them to wander into the realms of the unknown, and gives them the requisite strength to defy social prohibitions. In his work *The Paradox of Cruelty,* Philip Hallie emphasizes this type of drive: "Down to his core, the Gothic villain or the Devil he embodies is restless, ever-active energy, energy always intensified by single-mindedness."[1] This same frantic dis-ease is visually

apparent in the linear design of early Gothic ornament and later in the Gothic cathedral.

The earliest evidence of Northern ornament appears on the tombstones of Teutonic graves and subsequently in illuminated manuscripts and decorative carvings. This "linear fantasy"[2] is characterized by certain intertwining motifs, in earlier specimens the dot, line, and ribbon, and later the curve, circle, spiral, zigzag, and S-shape. The repertoire of motifs is extremely limited, but a great variety of combinations occurs. The shapes are knotted and twisted together in a frantic, springy, undulating pattern. They separate from one another, run parallel, and then cross again in a maze of latticed activity, producing "a fantastic spaghetti-like interlace"[3] "whose puzzle asks to be unraveled, whose convolutions seem alternately to seek and avoid each other, whose component parts, endowed as it were with sensibility, captivate sight and sense in passion-ately vital movement."[4] The restlessness of the design is reminiscent of the sleepless, puzzled, tortured souls who populate the Gothic novel and of the equally devious and allusive reality their twisted minds contemplate. This com-pulsion and lack of peace characterize the Gothic in all forms, preventing relaxation and the lapse into partial awareness. Gothic nervousness quickens the senses as more of the mind becomes awake to more of the world. Even in its embryonic state, Gothic art displayed the type of agitation that would continue to appear in Gothic architecture and literature.

The Gothic line can be described as both violent and unnatural, for it does not flow rhythmically back and forth in any sort of organic pattern. We could almost say that the Northern line is supernatural rather than natural, that it has surrendered to the fury of spirits dwelling within it, which drive it frantically first one way and then another in ecstatic, relentless activity. Wilhelm Worringer speaks of

The Gothic line, a spaghettilike interlace whose puzzle asks to be unraveled, is convoluted and unrelenting in its motion.

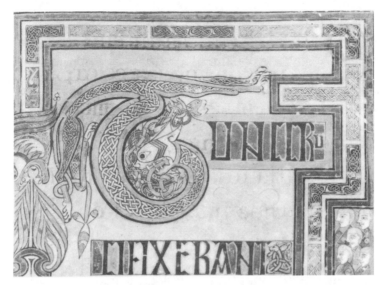

ABOVE: in Northern ornament, "Tunc" from the *Book of Kells,* now in Trinity College Library, Dublin. *Courtesy* Board of Trinity College, Dublin.

BELOW: in the Gothic Cathedral, Capital of a column from St. Sernin Cathedral at Toulouse. Photograph in *Medieval Sculpture in France* (Cambridge: Cambridge University Press, 1931). *Courtesy* Arthur Gardner.

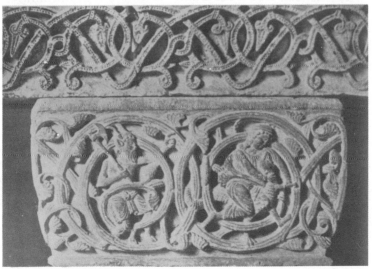

the unnatural quality of the Gothic line when he contrasts early Gothic ornament with Classical ornament. He describes Classical ornament as an extension of our sense of harmony. Classical man chooses the proportions within and around himself that he finds most pleasing and consciously, carefully applies them to his art.

> On the other hand, the expression of Northern ornament does not directly depend upon us; we are met rather by a vitality which appears to be independent of us, which challenges us, forcing upon us an activity to which we submit only against our will. In short, the Northern line does not get its life from any impress which we willingly give it, but appears to have an expression of its own, which is stronger than our life. [5]

Worringer illustrates his psychological analysis of line with an example from children's drawings. We can easily distinguish between the playful scribbling made by an idle youngster and the erratic, forceful, angry scribbles made by a disturbed child. We also know in ourselves the difference between the control exerted when doodling pleasurably and the desperation in frustrated scratchings. In the latter case we are overtaken by our emotions, and the course of our lines seems to follow a dictate of its own. In this sense Gothic ornament appears more emotional and less controlled than Classical ornament.

Worringer terms the Northern line *superorganic* rather than simply *nonorganic*, indicating that the line surpasses measured configurations.

> When once the natural barriers of organic movement have been overthrown, there is no more holding back: again and again the line is broken, again and again checked in the natural line of its movement, again and again it is forcibly prevented from peacefully ending its course, again and again diverted into fresh complications

of expression, so that, tempered by all these restraints, it exerts its energy of expression to the utmost until at last, bereft of all possibilities of natural pacification, it ends in confused, spasmodic movements, breaks off unappeased into the void or flows senselessly back upon itself.[6]

A force overcoming nature must be beyond nature, and so we speak of the supernatural in Gothic line. The theme of the unnatural or supernatural is certainly fundamental in Gothic literature, as is the sense of obstruction in the ordinary course of events. If we describe the Gothic line in art as repeatedly checked in the flow of its movement and thus strengthened by its need to seek devious resolution, we have visually approximated the excess of energy bred by repression in the Gothic novel. Irresolute hopelessness, lack of escape, surrender in the face of despair, and an eventual turning upon the self are typical attitudes in Gothic literature. The Gothic character submits to the will of superior powers, be they internal or external, spirits or fate.

Finally, Worringer speaks of "supersensuous activity" in Gothic art and of a need to be "freed from the direct feeling of thraldom to reality."[7] Worringer's choice of words in *Form in Gothic,* as well as Andrew Martindale's in *Gothic Art,* Marcel Aubert's in *The Art of the High Gothic Era,* or Charles Moore's in *The Development and Character of Gothic Architecture,* is remarkably applicable to Gothic literature when we consider that these art historians did not deal with Gothic literature or that literary critics had not distinguished any connection between Gothic art and literature beyond the use of the same word, which was considered an accident of etymology. Yet these art critics' descriptions belie a more basic correspondence. Gothic art, like Gothic literature, suggests an expanded reality when it threatens to break through the confines of linear space in its twisting inward and outward. In the absence of restriction, the intensity of movement in Gothic ornament is actually a picture of the intense, wide-awake souls incarnate in Gothic novels.

A total expansion of reality is impossible if we accept the limitations of a purely physical world. It is for this reason that Gothicism in literature stresses the spiritual, the penetration of the natural by the supernatural. Admittedly, it is more difficult for a comparable interpenetration of the physical and spiritual in a material art form as concrete as sculpture or architecture, but Gothic art has used every technique possible to minimize its physical restricitons. In other words, Gothic art attempts to dematerialize its composition in order to spiritualize its material components. The result achieved in art, as in literature, is the creation of a greater single reality in which the spiritual and physical merge.

In Northern ornament, once again, the convolutions of the line threaten the confines of physical space and can thus be interpreted as asserting the spiritual. The line does not appear to be a product of its space; it defies containment. Whether we speak of the line as emotional, psychological, or spiritual, a dimension beyond the physical is implicit.

Gothic architecture incorporated the spiritual quality of the Northern line into its entire structure, as well as into the decorative, spiral, plant tendrils adorning the capitals or the complicated carvings inside and outside the cathedral. In order to minimize the heavy quality of stone and stress its spirituality, Gothic architecture adopted flying buttresses and pointed arches to facilitate a towering, vertical structure unimpaired by internal supports. As a result, solid wall space could be reduced and great windows accommodated. The height and the open spaces achieved counteract the natural weight of stone, and the thrust of steep pinnacles opposes the pull of gravity. The joining of pillars to the cross ribs of the vaults through attached columns draws the structure up in a sweeping movement. The pillars do not appear to be supporting weight or to be pressing down, but rather soaring upward. Similarly, the outer towers do not

The soaring verticality of the Gothic cathedral opposes the pull of gravity and the natural weight of stone.

Cologne Cathedral, west front. *Courtesy* Helga Schmidt-Glassner, Stuttgart.

The dematerialization of stone resulted when solid wall space was minimized and large windows were accommodated as a result of pointed arches and external buttressing.

Cathedral of Sainte Chapelle, interior of upper chapel. *Courtesy* Lauros-Giraudon.

seem to burden the buttressing but rather to shoot skyward. If we speak in terms of active carrier and passive burden, these are "standing, not lying, buildings."[8] The structure of the Gothic cathedral, like the plot of the Gothic novel, is dominated by action, by both the tiny, frenetic movement in ornamentation or detail and the larger, sweeping, rising movements of construction or plot.

Another form of dematerialization appears within the intricate filigree carvings that cover the walls like a spider-web, the flowing fan tracery on vaults and windows, and the clutter of ornament on exterior walls, arches, portals, and towers. These carvings are often so incredibly delicate that it is difficult to believe they are actually made of stone. One carving at the Cloisters in New York brought there from a French cathedral depicts the Crucifixion of Christ, a crowd of people, and an entire city in more than thirty layers of overlapping perspective all within a cup-shaped oval little bigger than a walnut! Matter has been challenged here in that the stone seems to have dissolved into a tiny, magical world. In the whole of the Gothic cathedral, weight gives way to levitation. The capitals of columns, indeed the entire building, has lost its Romanesque heaviness; we could say it has been disembodied. Within the interior of the cathedral, a third spiritual effect is achieved by the stained glass windows, which create a sense of illusion through the colors and patterns they cast upon the stone.

The Gothic cathedral is designed to create a spiritually altered experience for those who enter, its great height and monstrous proportions dwarfing the viewer. The building is grossly out of proportion with human beings and seeks to emphasize their diminution in the face of larger and greater forces. The architecture shocks the viewer out of his normal perception of himself and distorts the magnitude of his surroundings, rendering the worshiper, like the victim in Gothic literature, at the mercy of supernatural forces within

Flowing fan tracery and intricate filigree carvings cover walls, vaults, and windows like a spiderweb and penetrate a world of ever tinier proportions.

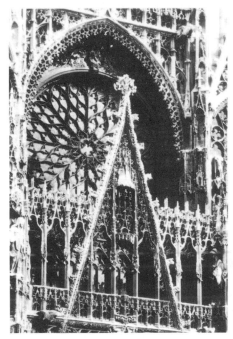

LEFT: Gloucester Cathedral, the southern walk of the cloister. *Courtesy* A. F. Kersling.

RIGHT: Rouen Cathedral, rose window and gable above the central doorway in the west façade. *Courtesy* Bildarchiv Foto Marburg.

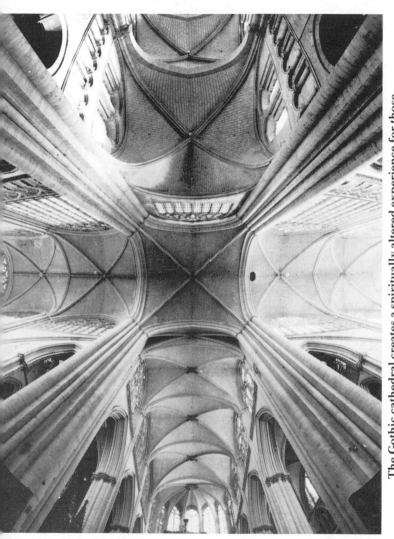

The Gothic cathedral creates a spiritually altered experience for those who enter, its great height and monstrous proportions dwarfing the viewer.

Cathedral of Le Mans, vaults. Photography by Bruno Balestrini, *Courtesy* Electra Editrice, Milan.

and beyond the self. The victim finally submits to these forces and to a changed perspective on reality. The longer one remains within the Gothic cathedral, the harder it is to project a human perspective. The structure ceases to appear abnormally large while the visitor perceives himself as abnormally small. This shock effect is not unlike that produced in Gothic literature, encouraging a keener perception of the self and the environment and an altered relationship between the two.

Gothic architecture evokes the world of the spirits in another way, which is at once more direct and more superficial than either its dematerialization or its altered proportions. The gargoyles and other carvings on the building designed to frighten away evil spirits are an obvious allusion to divine malevolence. The presence of pagan symbols on religious buildings also underscores a psychological connection between a sense of God and a sense of the grotesque, between religion and Gothicism.

The gargoyles also express an interest in psychology paralleling the psychological emphasis in Gothic literature. In his book *Gothic Architecture and Scholasticism,* Erwin Panofsky explicitly connects this sculpture with a renewal of interest in psychology. Insofar as the plant or animal in Gothic carving came to be considered an organism in itself rather than merely a copy of the *idea* of a plant or animal, Gothic art cultivated both individual variation and a closer study of nature. This naturalism can be seen in the individual species of vegetation and foliage appearing on the capitals of columns and in the extensive variety of flora adorning the entire building. In contrast to the inorganic treatment of nature in Classical art, the plants and animals in Gothic sculpture are very much alive. "Leaves and buds spring from growing stems, fruits depend naturally from their branches, animals live and leap."[9] An interest in particular variation is expressed in animal and human figures

Gargoyles and other carvings on the Gothic cathedral designed to frighten away evil spirits are obvious allusions to divine malevolence and are grotesque and menacing like the villains in Gothic literature.

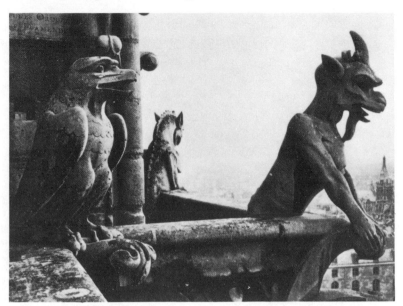

ABOVE: Notre Dame de Paris.

BELOW: Reims Cathedral, from the south arm of the transept. Photographs from Lester Burbank Bridaham, *Gargoyles, Chimères, and the Grotesque in French Gothic Sculpture. Courtesy* Architectural Book Publishing Company, New York, 1969.

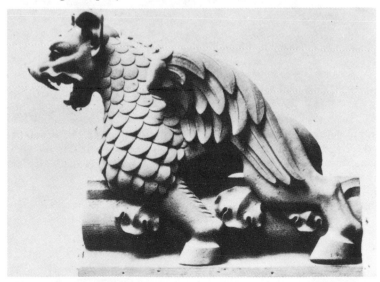

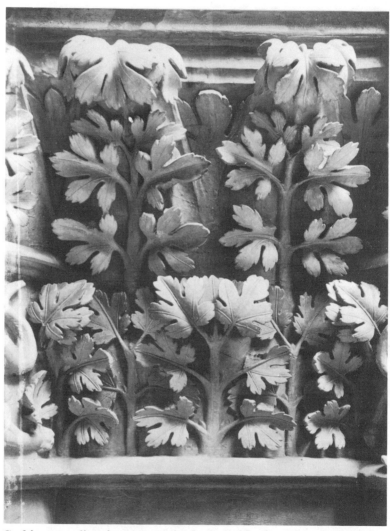

Gothic naturalism is apparent in the individual species of vegetation and foliage adorning Gothic architecture where a particular variety of plant rather than the *idea* of a plant is rendered realistically and organically.

Reims Cathedral, Capital. *Courtesy* Giraudon.

(or in combinations of the two) by particular facial expressions or body gestures that convey a range of psychological states from anger, hatred, fear, and pain, to joy or ecstasy. According to Panofsky, the perspective interpretation of space in these carvings also involved a subjectivism.[10] Accurate perspective facilitated the naturalistic portrayal of individual forms as opposed to a symbolic equivalent for all forms. Extreme subjectivity, to the point of distortion, is comparably present in Gothic literature.

The subjective realism in Gothic sculpture led to both individualism and sensualism.

> It is something new and stupendous in medieval ideas that the divine is no longer sought in non-sensuous abstractions, which lie beyond all that is earthly and human, in a realm of supernatural invariables, but in the center of the ego, in the mirror of self-contemplation, in the intoxication of psychical ecstasy. It is an entirely new human self-consciousness, an entirely new human pride, that deems the poor human ego worthy to become the vessel of God. Thus, mysticism is nothing but the belief in the divinity of the human soul, for the soul can look upon God only because divine itself.[11]

A self-conscious egoism and a reinsertion of the divine within the human is displayed in Gothic literature through the self-consciousness and egocentricity of its characters and through its general descendental mood. Besides human deification, the negative depiction of humanity and divinity (as seen in Gothic villains) is not totally absent in Gothic art, either. It is immediately apparent in the grotesque aspects of Gothic carving, but also in a progressive divisibility in Gothic architecture, the separation into smaller and smaller parts, that may in a hidden way hint of a breakdown, of decomposition, of individualism to the point of isolation. "The Northern individualizing process lead ... to self-negation to self-contempt. Individual character is

here felt to be something negative, in fact, even something sinful."[12] Hence the mystical need to transcend the self and the tragic inability to do so in the context of Gothic descendentalism.

The grotesque element in Gothic art, in gargoyles and carvings and even in altarpieces, is probably the most obvious parallel between Gothic art and literature. As was the case in Gothic literature, the grotesque in Gothic art is not achieved by an outright departure from reality but by a distortion of it or by unusual combinations. Naturalism is not really abandoned. In Moore's words:

> A remarkable quality of the grotesque creations of Gothic art is the close and accurate observation of nature which they, no less than the images of real things, display. However fabulous the imaged creature may be, the materials out of which he is made are derived from nature. Whether it be vertebra or claw, wing or beak, eye or nostril, throat or paw—every anatomical member displays an intimate familiarity with the true functional form, and an imaginative sense of its possible combinations with other members.[13]

The horror in these creatures is not otherworldly but disturbingly familiar; it is the more frightening for its fusion of good and evil, beauty and ugliness.

The Gothic refusal in literature to be limited to the beautiful or the moral is likewise a part of Gothic art.

> The representation of physical beauty being, with the Gothic carver, subordinated to the purpose of enforcing that the soul is more than the body, and of illustrating the doctrine of the salvation of the soul by the goodnes of life, and the loss of the soul by evil life, it was necessary that beings and things not beautiful should enter into his compositions. The evils that beset the lives and souls of men had to be in some way set forth, no less than the good things he is permitted to enjoy. The unhappy lot of the

wicked had to be figured as well as the felicities of the good. Hence conspicuous elements in Gothic sculpture, especially after the beginning of the thirteenth century, are the monstrous and the grotesque . . . and these elements have a value apart from their moral significance, as affording contrasts to the forms of beauty.[14]

Moore contrasts the principle of "inclusion" in Gothic art with that of "selection" in Classical art. The Greek artist selected the beautiful and rejected the ugly or imprecise, whereas the Gothic artist sought to represent the greatest vision and thus favored a principle of addition rather than elimination, indicating that beauty may coexist with imperfection in the wider range of existence. The principle that Moore calls inclusion Panofsky terms synthesis and totality, a totality rendered even more effective by the simultaneous subdivision in Gothic art. A greater breadth and greater vision—inevitably a vision of infinity—permeates both Gothic literature and art.

The inclusion of the ugly may also be related to the Gothic esteem for power. Moore noticed the importance of power in Gothic art. "This distinction between beauty of expression and power of expression is immediately applicable to the whole character of the two stylistic phenomena of Classic and Gothic art."[15] "Classical architecture culminates . . . in beauty of expression, Gothic architecture in power of expression; the former speaks the language of organic existence, the latter the language of abstract values."[16]

Just as Gothic architecture amplifies the intensity of reality, it expands its range by simultaneously exploring inward and outward, the minute and the immense. The tiniest of decorations are located within a towering edifice, and fragile pieces of colored glass are set in stone. The small and delicate aspects of Gothic architecture direct our attention inward toward an infinity of tinier and tinier divisions, progressive divisibility pointing toward a world within

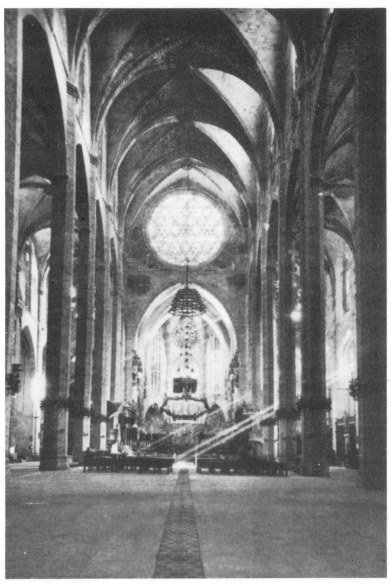

Contrast is evident in the Gothic cathedral between translucent, shimmering colored glass and solid, opaque stone.

Palma Cathedral, interior. Photograph from Paul Frankl, *Gothic Architecture*. (**London Penguin Books, 1962**).

worlds too small to be seen. During the height of the Gothic development supports were divided into main, major, minor, and subminor shafts; the tracery of windows, blind arcades, and triforia were subdivided into primary, secondary, and tertiary profiles and millions of ever-increasing complexity; and the arches and ribs were split into a series of moldings. These progressive divisions contrast with the enormous height and size of the exterior and the open, boundless interior, which direct our attention upward and outward toward an infinity of larger and larger proportions, toward the world beyond worlds too large and distant to be seen. The expansion in either of these directions challenges the mind to imagine the unimaginable.

In its erosive sense, divisibility in Gothic art may suggest fragmentation, disintegration, and decay, but in a cumulative sense, multiplication and repetition create the effect of infinite complication. With the ceaseless repetition of towers and pinnacles, the compounding of moldings and shafts, and the elaboration of lacelike spokes of tracery in windows, portals, arches, and buttressing, variety and complexity replace simplicity and contribute to the predominant sense of movement in Gothic art, a dynamism that parallels the fast-moving action of plot and the pervasive emotional agitation in the Gothic novel.

The great within toward which Gothic architecture points in its tiny intricacies and divisions-within-divisions is analogous to the great within in Gothic literature—the psychological recesses of the mind, the remote secrets of the unconscious. The great beyond in Gothic architecture suggested by greater and greater proportions and by the upward, vertical thrust can be compared to the great beyond in Gothic literature—the world of the supernatural, of forces beyond reason, knowledge, and control. Gothic architecture juxtaposes extremes of size, weight, and mass in much the same way that Gothic literature juxtaposes

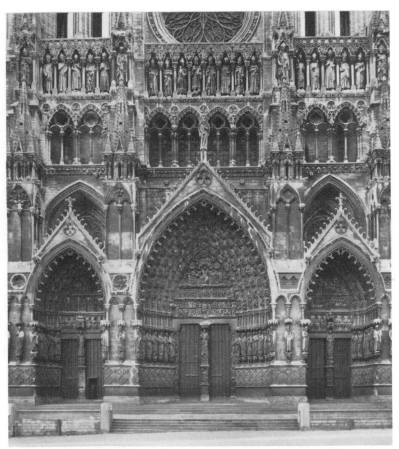

Progressive divisibility in portals, arcades, moldings, windows, and supports creates a sense of complexity and variety, a seemingly infinite multiplication of detail.

Amiens Cathedral, west façade. *Courtesy* Hirmer Fotoarchiv München.

extremes of color, sound, setting, and character. (Gothic sculpture of the Middle Ages and the foliage and animals that ornamented the cathedral were often painted in simple, contrasting colors, as were the decorative borders of illuminated manuscripts.) Sharp contrasts can also be seen texturally in the sculptured drapery on figures where the ridges are pronounced with deep hollows between them.

A contrast in thrust is operative in the flying buttresses where, in a sense, the building has been built too high to support itself. An overextension of height leads to an excessive outward pressure that must be countered by the inward pressure of the flying buttresses with added weight from the towers. A juxtaposition of excessive thrusts maintains the structure rather than an initial, self-contained equilibrium.

Persistent repetition is a key technique in Gothic art contributing to a sense of infinity. Repetition is crucial to any form of art, be it in a repeating color scheme, basic linear patterns, or selected motifs, but in Gothic art repetition is less modified. In Classical art, repeated lines and forms usually appear in reverse, creating a mirror image to complement the original and conveying a sense of completion and serenity. Hurried, mechanical repetition is always avoided in the Classical. In Gothic art, however, a ceaseless pounding of identical strokes suggests the infinite persistence of a particular form. Such reappearance at regular intervals creates the type of immediacy that Edgar Allan Poe produced through auditory repetitions, such as the ticking of a clock, the dripping of water, or a pounding heart. In Gothic architecture vertical lines repeat themselves from pillar to pillar, and in Northern ornament and Gothic sculpture repetition continues without accentuation or pause, building to a state of frenzy. Some critics consider this exalted hysteria the distinguishing characteristic of Gothic art. Every inch of available space is covered with ceaseless activity. Gothic art is never still as it pushes for

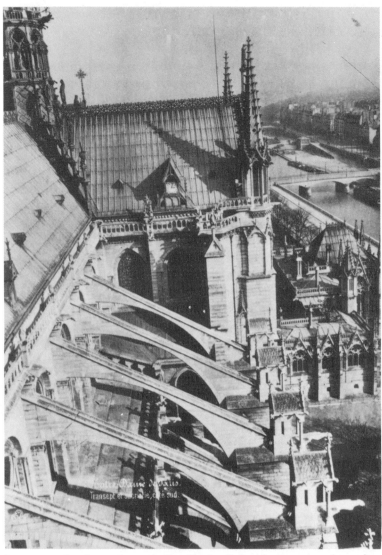

A contrast in thrust is operative in the flying buttresses where, in a sense, the edifice has been built too high to support itself.

Notre Dame de Paris, south side near transept and sacristy.

Photographs from Lester Burbank Bridaham, *Gargoyles, Chimères, and the Grotesque in French Sculpture. Courtesy* **Architectural Publishing Company, New York, 1969.**

greater visual awareness. "It uses the tumult of sensations to lift itself out of itself."[17] This is the same intoxication and indulgence displayed in Gothic literature.

A strong movement propels the entire structure of Gothic architecture both vertically and horizontally. Pointed arches obviously accentuate an upward motion, yet they also contribute to a longitudinal direction in that they make possible the vaulting of oblong areas. (With the rounded arch only square areas could be vaulted.) Furthermore, with the use of pointed arches, both the bays and the main aisles could rise together. The addition of ribs to cross vaulting (and the more important structural innovation of having the ribs bear the weight of the vaults) also created a sense of linear movement and produced the illusion of rising height at the center point where the sectroids meet. The attached columns that join the pillars to the ribs give even heavy pillars a sense of soaring movement as the eye is led upward to the peak of the vault. The body of Gothic architecture has "taut sinews and pliant members ... without any superfluous flesh or any superfluous mass"[10] like the lean, bony, angular characters whose quick, furtive movements and dramatic actions hurry the pace in Gothic novels. The double movement in Gothic architecture can be contrasted with the single movement in earlier church architecture. Artistically, the early Christian basilica had one definite goal—the altar. The Gothic cathedral moves both toward the altar and toward heaven (although the vertical movement is clearly stronger). The simplicity of the basilica with its single, tangible goal gives way in the Gothic to a less definite, infinite location.

In a philosophical if not visual manner, the use of perspective in the interpretation of space, mentioned earlier in connection with the grotesque, lends "visual expression to the concept of the infinite; for the perspective vanishing point can be defined only as the projection of the point in

which parallels intersect."[19] Intellectually, the inclusion of endless variety in the representation of different plants and animals also points toward infinity by informing the viewer of the unending variety of God's creation. These carvings "induce a sense of infinity by permitting the beholder to submerge his being in the boundlessness of the Creator Himself."[20]

Beyond the suggestion of infinity, repetition functions as an organizing principle in Gothic art that replaces symmetry. In Northern ornament there is little attempt to harness the activity of the line or force it to conform to the rules of balance and proportion. There is rarely a center in these ornaments, and when a center is present, the movement is peripheral rather than radial. (The eye follows the pattern round and round on the periphery.) In the eccentric Northern ornament the eye is led through a labyrinth without the pattern of a self-contained whole. "Every point in this endless movement is of equal value and all of them combined are without value compared with the agitation they produce."[21] Asymmetry communicates a living dynamism; it is not absolute, like a geometric figure, and is lifelike in its irregularities. Gothic architecture is also markedly asymmetrical; the building is without a center; one side need not mirror the other. Just as the line in Gothic ornament does not circumscribe a space, so too in Gothic architecture lines indicate movement rather than encompass an area. Space is not shaped and enclosed but dissected. The internal volume is not defined by firm walls or shaped by an arching vault, for Gothic architecture gradually perfected a rudimentary skeleton of piers, arches, and buttresses that freed the walls from structural support and thus from their inert massiveness.

In Gothic literature plot and characters are often stereotyped and repetitive. We follow them through a maze of ceaseless complications that seem to defy organization as

well as the laws of probability. The plot structure itself is asymmetrical insofar as it is often difficult to locate the climax toward which the action builds and from which it declines. A rapid palpitation prolonged uninterruptedly replaces development. In the Gothic novel the process rather than the outcome is crucial. (Try to remember the resolution in *The Castle of Otranto, The Mysteries of Udolpho,* or even *Dracula.*)

Both Gothic art and Gothic literature are not self-contained. Symmetry and centricity create a sense of order and completion. We see it all; all is controlled. Gothic creation, however, is "on the way"; it is incomplete. The work of art spreads out from itself at will and goes where the forces of chance or fate may take it. In the end there is no pattern, no answer. The process of life for the Gothic soul is beyond reason, and contact with life takes place beyond the confines of orderly illusions or restrictive limitations. Gothicism tells people that they must surrender to the process of living and to the forces of an uncertain future. In this surrender one is heedless of the balancing principles of art or society. The goal is the process itself, an intensified perception of a limitless reality.

NOTES

1. Philip Hallie, *The Paradox of Cruelty* (Middleton, Conn.: Wesleyan University Press, 1969), p. 67.

2. Wilhelm Worringer, *Form in Gothic* (London: G. P. Putnam's Sons, Ltd., 1927), p. 41.

3. Andrew Martindale, *Gothic Art* (New York: Frederick A. Praeger Publishers, 1967), p. 140.

4. Lamprecht, quoted in Worringer, *Form in Gothic,* p. 41.

5. Worringer, *Form in Gothic,* p. 42.

6. Ibid.

7. Ibid., pp. 44-45.

8. Wilhelm Worringer, *Form Problems of the Gothic* (New York: G. E. Strechert and Company, 1912), p. 97.

9. Charles Herbert Moore, *The Development and Character of Gothic Architecture* (New York: The Macmillan Company, 1890), p. 24.

10. Erwin Panofsky, *Gothic Architecture and Scholasticism* (New York: Meridian Books, 1960), p. 16.

11. Worringer, *Form Problems,* p. 139.

12. Ibid., pp. 144-45.

13. Moore, *Development and Character,* p. 266.

14. Ibid., p. 265.

15. Ibid., p. 51.

16. Ibid., p. 87.

17. Worringer, *Form in Gothic,* p. 73.

18. Worringer, *Form Problems,* p. 120.

19. Panofsky, *Gothic Architecture,* p. 17.

20. Ibid., p. 19.

21. Worringer, *Form in Gothic,* p. 54.

[3]
Particular Works of Gothic Literature

A Gothic novel is not merely a collection of the characteristics that typify the genre but a unique entity of its own in which the Gothic landmarks merely set the scene and tone. In other words, each work has it own way of presenting the Gothic vision, its own personal brand of characters and images, incidents and assessments. The particulars within the novel are analogous to the general identifying traits of the genre for they also mirror an expanded, intense reality; the juxtaposition of extremes or the prolongation of intensity can be discovered within each author's story or imagery just as they are fundamental principles for the Gothic style.

The five works that will be examined here are representative of five different periods and schools of Gothic writing. Of the four nineteenth-century works, two were written in the earlier part (*Frankenstein* in 1818 and *Melmoth the Wanderer* in 1820), one in the middle of the century ("The Haunters and the Haunted" in 1859), and one near the end (*Uncle Silas* in 1899). The one twentieth-century work, *On the Night of the Seventh Moon,* will be compared with the earliest novel under consideration in order to demonstrate the similarities between a modern, realistic version of the Gothic and an older, romantic type. Although it is dangerous to rigidly classify Gothic works, *Frankenstein* might be categorized as Romantic Gothic, *Melmoth the Wanderer* as

both more mystical and archaic in style, *Uncle Silas* as Victorian Gothic within the school of terror, "The Haunters and the Haunted" as Scientific Gothic, and *On the Night of the Seventh Moon* as Psychological Gothic.

[4]

Melmoth the Wanderer
by Charles Robert Maturin

THE restless Gothic line–at once agonizing and impetu-
ous–is outstanding in the setting, character, imagery, plot
development, syntax, and word choice in *Melmoth the Wan-
derer,* and in the fluctuation of emotional states, the flow of
time and its interruption, and the convolution of logic. In
the third volume of this lengthy novel the plight of one
character is described:

> There is not perhaps a more painful exercise of the
> mind than that of treading, with weary and impatient
> pace, the entire round of thought, and arriving at the
> same conclusion forever: then setting out again with
> increased speed and diminished strength and again
> returning to the same spot–of setting out all our faculties
> on a voyage of discovery and seeing them all return
> empty.[1]

Maturin's description of the Gothic agony echoes Wor-
ringer's analysis of the Gothic line–the tortured struggle
that fruitlessly repeats itself, the driven, compulsive energy
that increases with frustration, and the empty quality of the
line that does not circumscribe a space but dissects it in
endless tangles. This spiritually restless line permeates the
wandering complexities of Maturin's novel.

This work is filled with frantic, tortured characters, foremost among whom is Melmoth himself, "a restless, homeless, devoted being." Isidora is another "restless eccentric" led to resolutions wild and desperate, which she later renounces. She clothes herself in flowers with peacock feathers twined among them, her hair, too, laced with flowers and feathers. Melmoth renders her increasingly anxious until she breaks through her chains in a desperate fury, borne on with supernatural velocity. Donna Clara, Isidora's mother, has been disfigured by the "ligatures which the hand of custom had twined round it since its first hour of consciousness." She is most often sewing or writing letters, having so much to correct, modify, and expunge that her epistle actually resembles her tapestry. With "inextinguishable and remorseless assiduity," she busily overcasts her grandmother's embroidery, the new work making havoc among the old. (At times the long descriptions of her sewing seem equally remorseless, often running on for pages.) Walberg, another central character, reaches a desperate state in which his "horrid thoughts chase each other over his reeling and unseated mind." Of the withered Sybil, who attends John Melmoth's dying uncle, it is said: "No one twined so well as she the mystic yarn to be dropt into the lime-kiln pit," and the old woman who works for the uncle speaks in "endless circumlocutions." Elinor's hair, like Isidora's, is twisted, "the thousand small curls into which . . . it was woven, seemed as if every one of them had been twined by the hand of nature." Mentally and physically, Maturin's characters are twisted souls.

In setting too, a winding, crooked course is traced. "The way lay through a rocky road that wound among mountains, or rather stony hills" (3:266). "There had been a path, but it was now all obstructed by stones, and rugged with the knotted and interlaced roots of the neglected trees" (p. 66). "Their trunks were as adament, and the interlaced branches

seemed to twine themselves into folds" (1:169). There was "a narrow and precipitous path close by a shallow stream," and one could hear the "hoarse and rugged sound of its waters as they fought with every pebble to win their way" (3:56). There is "vegetation that loves to shoot its roots, and trail its unlovely verdure amid the joints of grave-stones" (p. 67), and there are paths "entangled by the intersecting roots of trees" (p. 266).

In imagery weaving and webs constantly recur. In volume 3 alone there are twelve pages exclusively devoted to descriptions of tapestry. Elinor dreams of a "web too fine to be woven in the web of life." The Inquisition is described as the "fortress of the spider who hung her web on its walls." Isidora speaks of "the chrism-mantle . . . of that mysterious darkness which your fingers have woven." Alonzo observes that his companion has *"twisted my cold fingers* in the ropes of the ladder," and such phrases as "restless agony," "restless and unappeaseable anxiety," "windings of doubts," and "hot and anxious pursuit" appear again and again. We are "entangled in the snares of Satan," "we shall wind round the roots of it," women are "twined round us," we are subject to the "felicities and agonies which are inseparably twined with the fibers of conjugal and parental hearts," and death breaks "every tie that was twined with it." At one point Maturin attacks the romantic notion that people's lives are directed by a single, clear motive, arguing instead that life consists of a tangle of random forces. The soul does not exert itself in one great effort but is exhausted by eternally recurring domestic conflicts. Maturin's images suggest a world of gain and loss, advance and retreat, in which energy is spent in overlapping aversions and motivations.

The twisted Gothic line is most strikingly conveyed in Maturin's convoluted plot progessions. The story will be moving in a certain direction when suddenly it dashes off in another. Numerous twists in the plot are created when

action gives way to an opposite reaction and then to a third reversal followed by other reversals, all in rapid succession. Bizarre coincidences facilitate these deviations and accelerate the rate of the plot. At one point in the novel the Walberg family is starving to death as a result of being excluded from Guzman's will. After prolonged suffering, the wife (Ines) finally drops dead when she hears that her husband (Walberg) is willing to sell his soul in exchange for some food for his family. As soon as Ines dies, Walberg charges into the bedroom and strangles his children rather than watch them slowly starve. Up to this point in the action the entire scene has been related to the reader through Walberg's convoluted monologue to his wife.

> "You are wasted to a shadow with want! Show me the means of procuring another meal, and I will spit at the tempter, and spurn him!–But where is that to be found? Let me go, then, to meet him!–You will pray for me, Ines, will you not?–and the children?–No, let them not pray for me!–in my despair I forgot to pray myself, and their prayers would now be a reproach to me–Ines!–What? am I talking to a corpse?" He was indeed, for the wretched wife had sunk at his feet senseless. "Thank God!" He again emphatically exclaimed as he beheld her lie to all appearance lifeless before him. "Thank God a word then has killed her–it was a gentler death than famine! It would have been kind to have strangled her with these hands! Now for the children!" (3:134)

This monologue erratically twists from a description of Ines's condition to the tempter who could provide food, to a supplication for Ines's prayer, to Ines's apparent refusal to pray, to the request that the children pray, to the immediate withdrawal of that request, to Walberg's own failure to pray, to Ines's death, to Walberg's acceptance of death, and to Walberg's resolution to strangle his children–all within one paragraph! The frantic action continues unabated, for

just as Walberg finishes strangling the children, some messengers come to the door to inform him that Guzman's first will was a fraud and that in the real will his family has been left a fortune. (The messengers would have arrived the previous night, but they met up with Walberg's son and were sidetracked.) At this moment Ines recovers from her seeming death (she was not actually dead, we discover, but only in a deathlike stupor) and breaks into great joy upon hearing the news. However, when she dashes into the children's room and discovers them strangled, she swoons upon their lifeless bodies. But lo and behold, we discover that the children are not really dead either (they had only stopped breathing to feign death and thereby ward off their father and, in the process, had fainted from lack of oxygen), and after the children awaken, their mother slowly regains consciousness. By this time, however, Walberg has lost his senses, and both wife and children struggle with him throughout the night until he finally comprehends what has happened. This entire series of events takes place in less than eight pages.

The proximity of desire and fulfillment further accounts for frantic action in a limited area. Isidora stands in the garden and desperately longs for Melmoth, "Oh that he were but here," and in the very next sentence he arrives! Sometimes rapid reversals follow long sections that lead the reader to expect a lengthy resolution. Surprisingly, though, the episode is abruptly brought to a close by a succession of hurried occurrences. In the section of the novel relating to the love between Elinor and John Sandal, John has lost his mind and is patiently cared for over the years by Elinor. Maturin leisurely describes their silent walks together, Elinor's thoughts as she cares for John, their gradual aging, and Elinor's tireless devotion. Then John returns to his senses, unsuccessfuly attempts to speak to Elinor, immediately dies, and then Elinor dies—all in three sentences.

Sometimes complex motives are not revealed gradually but are withheld until the end of an episode and quickly divulged in a twisted heap. Not until John's wife, Margaret, is on her deathbed and has nearly stopped wondering (as has the reader) why John abandoned Elinor on her wedding night years before his marriage to Margaret, does John's mother explain that she had lied to her son, telling him that she was not his real mother and that he was Elinor's brother. In this way she prevented John from marrying his supposed sister, making it possible for him to marry Margaret and inherit considerable wealth.

Action may begin to curve in one direction and then take another turn, as when Fra Jose comes to visit Isidora in prison and their meeting is suddenly interrupted. "Fra Jose melted at the appeal, and he was about to bestow many a kiss and many a prayer on the wretched babe, when the bell again was sounded, and hasting away, he had but time to exclaim. . . ."

Many of the strangest surprises are facilitated by unexpected emotional twists. Maturin prepares the reader for a paticular response, yet a completely unexpected one occurs. After a nine-page conversation in which Melmoth relentlessly tries to persuade Isidora (also called Immalee) to give herself to him, Isidora finally consents, and then Melmoth suddenly reverses his position.

> "Would you indeed be mine?–my own–my Immalee?"–"I would–I will!"–"Then," answered Melmoth, "on this spot receive the proof of my eternal gratitude! On this spot I renounce your sight! I disannul your engagement!–I fly from you forever!" And as he spoke he disappeared. (3:21)

In a second unexpected reaction, Isidora is surprisingly calm and unaffected.

Isidora was so accustomed to the wild exclamations and (to her) unintelligible allusions of her mysterious lover, that she felt no unwonted alarm at his singular language, and abrupt departure. (3: 21)

Even more peculiar is Elinor's sudden acceptance of John, her former lover, who had jilted her on her wedding day, causing her to flee the castle in tears and subsequently spend the remainder of her days in declining health. However, on the death of her cousin Margaret (whom John has since married), Elinor's romantic love abruptly dissolves. After pages and pages have been devoted to the agony that Elinor experienced at even the thought of John, this instant emotional immunity is hardly expected. For years Elinor has strenuously avoided the castle for fear of seeing John, but now she suddenly heads for the castle without the slightest trepidation.

Strange twists in the time sequence of the novel cause different episodes to buckle over upon themselves in order to occur simultaneously. Donna Clara reads a letter from Francisco di Aliaga in which he describes the clock as striking three, and just at that moment the clock also strikes three in Donna Clara's home. Maturin makes much of this coincidence, leading the reader to think that somehow time has stood still, that the writing of the letter and its later reading are happening at the same time.

Disruptions in the sequence of events forestall the climax of the novel and prolong tension. For example, the episodes involving the Walberg family and the Mortimers are inserted right in the middle of the first section of the novel (concerning Isidora and Melmoth), so that the resolution of the first story is postponed until the very end of the book. Such insertions further avoid straightforward presentation, sidetracking the course of development at the same time that they maintain suspense.

Convoluted patterns are evident not only in setting, characterization, and plot development but even in the sentences themselves, which are often exceedingly complicated, filled with subordinate clauses and digressions that wind their way for pages, punctuated by numerous commas (commas that are in fact too numerous and grammatically superfluous), dashes, semicolons, parentheses, and quotation marks within quotation marks. One such sentence (I will spare the reader and not quote it here) runs for three full pages (3:178-80). An example of a slightly shorter though not less complex sentence can serve as an illustration.

> "This is the text on which he preached, and his eloquence had such an effect on the daughter of Sir Roger Mortimer, that, forgetting the dignity of her birth, and the loyalty of her family, she united her destiny with this low-born man; and believing herself to be suddenly inspired from this felicitous conjunction, she actually outpreached two female Quakers in a fortnight after their marriage, and, wrote a letter (very ill-spelled) to her father, in which she announced her intention to suffer affliction with the people of God," and denounced his eternal damnation, if he declined embracing the creed of her husband;—which creed was changed the following week, on his hearing a sermon, from the celebrated Hugh Peters, and a month after, on hearing an itinerant preacher of the Ranters of antinomians, who was surrounded by a troop of licentious, half naked, drunken disciples, whose vociferations of— "We are the naked truth," completely silenced a fifth-monarchy man, who was preaching from a tub on the other side of the road. (3:169)

Contortions within a single sentence are even more obvious and ludicrous when they encompass violent action.

> Amid the thickest of the fight, in an open boat, he [John Sandal] had carried a message from Lord Sandwich to the Duke of York, under a shower of balls, and when older officers had stoutly declined the perilous errand;

and when, on his return, Opdam the Dutch Admiral's ship
blew up, amid the crater of the explosion John Sandal
plunged into the sea, to save the half-drowning, half-
burning wretches who clung to the fragments that
scorched them, or sunk in the boiling waves; and then,–
dismissed on another fearful errand, flung himself be-
tween the Duke of York and the ball that struck at one
blow the Earl of Falmoth, Lord Muskerry, and Mr. Boyle,
and when they all fell at the same moment, wiped with
unfaltering hand, and on bended knee, their brains and
gore, with which the Duke of York was covered from
head to foot! (3:190)

By the end of this sentence, we may not at first remember that
he is the subject of the verb *wiped*. (In the interim we have
been introduced to Lord Sandwich, the Duke of York,
Opdam the Dutch Admiral, the Earl of Falmouth, Lord
Muskerry, and Mr. Boyle, as well as numerous older officers
and half-drowning, half-burning wretches.)

Some digressions involve many sentences, rambling on for
pages. One five-page account of a letter Donna Clara is
writing is complicated by descriptions of her writing process—
her false starts, corrections, interruptions, additions, and
deletions. The letter begins with Donna Clara's statement
that her daughter is deranged and that the infirmity should
not be mentioned to the daughter's fiancé, and proceeds to
detail the nature of the daughter's fantasies, why the de-
rangement will not affect her marriage, and how the future
husband will in all likelihood handle the situation. (There are
insertions in parentheses about how Donna Clara cannot lie
about these matters since Fra Jose is writing down her words.)
In order to illustrate her daughter's insanity, Donna Clara
launches into an account of a recent incident in a church (a
story that, Donna Clara adds, proves her daughter neither
sane nor insane), followed by a debate between Donna Clara
and Fra Jose about the wording of the story and a description
of Isidora's introduction to the church on the night of

penitence during Passion Week, including the self-macerations performed there, Isidora's impression of them, and her later reaction to an assembly held at the expiration of Lent (full analysis of Isidora's dualistic theology not omitted). The ending of the letter is never given but is summarized:

> These and many similar anecdotes were painfully indited in Donna Clara's long epistle, which, after being folded and sealed by Fra Jose (who swore by the habit he wore, he had rather study twenty pages of polyglot fasting, than read it over once more), was duly forwarded to Don Francisco. (3:45)

This letter is answered by an equally digressive letter that Donna Clara receives from Don Francisco. Considering the fact that the letters themselves are irrelevant to the story, the multiple digressions within the letters and in the description of the letter-writing process are digressions within digressions, tangles within tangles in typical Gothic form which boggle the mind by their very intrigue or become, as in this case, a source of humor. Maturin satirizes the Gothic mentality by exaggerating it and applying it to trivia. Nonetheless, both his more serious sections and his spoofs trace a characteristically Gothic design.

The multiple narrations that frame the different tales are structurally digressive. Each tale is told by a teller who is often a character in either that tale or another, and the entire series of tales and tellers is presented as an account in an old manuscript told to John Melmoth by Alonzo Moncada. Within the jumble of stories and speakers the reader often loses track of which story is within which story or which narrator is speaking. Maturin acknowledges this confusion when he states: "Young Melmoth (whose name perhaps the reader has forgot). . . ." The storytelling process has become so confused that the reader can no longer be sure where it is coming from.

Like the final curlicues on a spire encrusted with orna-
ment are the extraordinary, often ridiculous footnotes that
decorate the novel. One such footnote occurs in a section
relating to the site of a battle. "This double exercise of the
sword and the word, however, proved too much for the
strength of the saint-militant; and after having driven
Cromwell's Irish campaign, [he] vigorously headed the
attack on Cloghan Castle, [1] the ancient seat of the O'Moores,
princes of Leix." The footnote itself, printed on the
bottom of the same page and continued on the next, reads:

> [1] I have been an inmate in this castle for many months—it
> is still inhabited by the venerable descendant of that
> ancient family. His son is now High Sheriff of the King's
> county; Half the castle was battered down by Oliver
> Cromwell's forces, and rebuilt in the reign of Charles the
> Second. The remains of the castle are a tower of about
> forty feet square, and five stories high, with a single
> spacious apartment on each floor, and a narrow staircase
> communicating with each, and reaching to the bartizan,—
> and how it got or grew there, heaven only knows. There it
> is, however, and it is better to see it there than to feel the
> discharge of hot water or molten lead from the apertures.
> (3:167-68)

Confusions of both time and person are involved here, and
the reader does not know who is supposed to be speak-
ing—the storyteller of the particular tale within which it
occurs (in this case the second stranger whom Don Fran-
cisco met during his travels and whom the reader later
discovers to be Melmoth the Wanderer), the speaker who
recounts this entire section (Moncada), the author who
wrote the manuscript that Moncada has translated (Adoni-
jah the Jew), the character who is retelling what Moncada
has related to him (John Melmoth), the real author of the
entire novel (Charles Robert Maturin), or perhaps even
some later editor who published this edition of *Melmoth the*

Wanderer. The person speaking in the footnotes seems to suggest that he is *presently* incarcerated when he says "I *have been* an inmate in this castle for many months," yet none of the possible speakers has been described as imprisoned. Perhaps a new scene and time, if not a new voice, has been interjected. The footnote follows a winding path that is further complicated by the unanswerable questions it raises.

The multipliction of speakers in the body and footnotes of the narrative functions in a second way to telescope reality, penetrating the tales within tales. Most paragraphs in the novel begin with quotation marks to remind the reader that Moncada is speaking to John Melmoth, and within these paragraphs other quotation marks appear as Moncada quotes a succession of narrators who in turn quote other characters. For example, within one tale told by Moncada, Adonijah quotes Isidora and Melmoth directly and also cites Donna Clara's accounts (in letter form) of what has happened to Isidora as well as Don Francisco's account (in letters, speech, and thought), of what has happened to him. A second episode recorded by Adonijah, entitled "The Tale of the Guzman's Family is told to Don Francisco by a stranger who is really Isidora's father from the first tale. Thus this tale is a tale within a tale all within Adonijah's tale, which is in fact within Alonzo's tale retold by John Melmoth within Maturin's novel. Within the Guzman tale the stranger speaks directly, for example: " 'Of what I am about to read to you,' said the stranger, 'I have witnessed part myself, and the remainder ...' " and he also quotes the characters he describes. The reader encounters dialogue (by the characters) within narration (the stranger's) within a manuscript (Adonijah's) within narration (Moncada's) within narration (John Melmoth's). Such concentric enclosures suggest realities within realities.

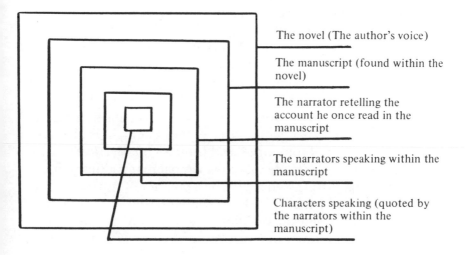

The novel (The author's voice)

The manuscript (found within the novel)

The narrator retelling the account he once read in the manuscript

The narrators speaking within the manuscript

Characters speaking (quoted by the narrators within the manuscript)

The reader is thus telescoped into one of the tales, but he soon forgets that this tale is being recounted within another. Maturin encourages this temporary lapse of perspective by not mentioning the speaker for many pages, allowing him to become invisible or identified with the author's voice. For example, on page 161 of the novel, where a stranger begins to speak, such expressions as "the stranger proceeded" or "Aliaga said" are included. However, neither the stranger nor Aliaga is mentioned again anywhere in the next ninety-two pages. Then, on page 253, the stranger and Aliaga are inserted again. " 'It was at this period,' said the stranger to Aliaga, 'I first became acquainted with . . .' " and suddenly the tale within the tale snaps back into perspective. Maturin has penetrated into a story within a story, expanding an inner dimension, and then plunged back again to the outer story, thus developing in both inward and outward directions.

Sometimes the identity of a particular narrator is lost in the plethora of speakers, as in the tale about Isidora and Melmoth the Wanderer retold by Moncada to John Melmoth (Melmoth the Wanderer's ancestor). Maturin writes, "To the mere reader of romance, it may seem incredible that a female of Isidora's energy. . . ." The reader naturally assumes that this phrase, like the rest of this section, was spoken by Moncada (the quotation marks indicate that someone is being quoted), yet the statement is directed to the "reader of romance," and John Melmoth is *listening* to Moncada. Is it possible that the original manuscript written by Adonijah addressed itself to "the reader of romance" and that Moncada has somehow remembered this sentence exactly and relates it verbatim? More likely, the author is speaking about his romance (about a story within a manuscript), yet if Maturin himself is speaking, why are his words in quotation marks? Who is quoting him? The reader is suspended between perspectives when he reads such statements. He finds himself wandering between realities in an eerie, undefined limbo.

In the expansion of reality created by the addition of voices, the footnotes provide the outermost extension. One such footnote reads, "[1] Here Moncada expressed his surprise at this passage (as savouring more of Christianity than Judaism), considering it occurred in the manuscript of a Jew" (3:61). Since the footnote refers to Moncada, it is clear that Maturin must be speaking (rather than Moncada himself) and thus the footnote pulls the reader out of Moncada's narration and reframes this account within the greater novel. Often the minutia of detail is bizarre, thus exploding the critical viewpoint into a joke. One footnote reveals: "[1] As this whole scene is taken from fact, I subjoin the notes whose modulation is so simple, and whose effect was so profound." Two staffs of music are presented here in four-part harmony (complete with grace notes), including treble and bass

clefs, two flats, and four/four time. Finally, those footnotes which suggest additional editors through their obscure references and exclamations add still another retreat from the text, introducing dimensions beyond the novel.

Maturin's use of the manuscript, of a book within his book, obviously contributes to his framing and reframing, but it also involves an implicit contrast between silence and sound that has been developed thematically in the novel. Maturin has us imagine people who first speak; their speech is preserved in a silent manuscript; the manuscript is later read aloud by a narrator; and the narration is then recorded in the novel (which is read silently by the reader). Further, within the novel there are written letters and documents that enjoy oral readings. At one point Maturin writes, "As they spoke, ... as it is sublimely said in the original, there was neither speech nor language." Again that hazy, intermediate region.

Manuscripts appear very often in Gothic novels because they tantalize the Gothic thirst for the omnipotent and eternal. Like ruins, manuscripts are remains from the past; they restore the memory of earlier times, bringing them into the present. Maturin stresses that parts of the manuscripts have been irrevocably lost, as has the entire past whose shadow is preserved through memory and written records. A scrawl of lines on a thin piece of paper, the manuscript militates against eternal obscurity; in its partiality it hints at the greater past the way a corner of a tree in a painting (cut off by the edge of the canvas) leads us beyond the picture itself to imagine the entire tree. In another sense, the written word is omnipotent; the author dictates, "there shall be," he commits his words to paper, and his image comes to life in the minds of his readers. The power of the written word and the absolute obliteration of the past that is its alternative are among the bold, sweeping contrasts that please the Gothic soul.

The twisted Gothic line that worms its way into every nook and cranny of the present and past is the first principle in Gothic art apparent in *Melmoth the Wanderer*. Unvaried repetition is the second. Maturin repeats a series of words with unusual frequency,[2] most often in fast-moving, tension-filled sections. These words take on the quality of a chant that begins to sound infrequently (softly in the background) when tense episodes approach and that then is heard more persistently (or louder) as the tension builds. They become a pulse rate for the plot, a familiar, pounding, relentless incantation warning the reader about exciting sections and accelerating them.

I have counted these words throughout volume 3 of the novel in order to demonstrate their appearance and proximity. Even without counting, though, the casual reader would become aware of them. Fourteen words occur with unusual frequency in the novel. In order of frequency they are: *night, day, light,*[3] *silence, dark, wild, evening, whisper, cold* (and *chill*), *glory, morning, delight, shade* (and *shadow*), *path, embroidery* (and *thread*). (The sense of these words is also repeated in other phrases that have the same meaning; for example, in connection with the word *silence,* "the absence of sound," "said not a word," "uttered not a word," or a "speechless emotion.") Sometimes the words are used in a repetitive and rhythmic way within a single sentence: "She sat in silence, and this silence ..." or "The day dawned, and at the dawn of the day. ..." The two most common words, *night* and *day,* sound an eerie rhythm while creating contrast, as do *morning* and *evening,* and the recitation of the seasons. Nearly half of the most repeated words fall into sets of opposites, while two others, *whisper* and *shade,* describe transitional stages between opposites (a whisper is the edge between sound and silence, and shade between light and dark). Three other transitional words, *narrow* and *shallow*—states of width and depth between absence and presence, and *dim* (also *pale*)—between light and dark, were also repeated, though slightly less frequently.

The tale of the Guzman family aptly exemplifies the correlation between tension-filled sections and word frequency. The story at first moves rather slowly for seven pages as the characters and their situations are introduced. Then the action begins to speed up as Walberg, the main character, is informed that his brother-in-law, Guzman, who had become very ill, has suddenly decided to receive his sister, forgive her, and leave his wealth to her family. However, when the family returns to Germany, Guzman recovers and begins to reconsider his generous offer. The penniless family then waits in suspense for Guzman to make up his mind. During the introductory pages 78, 79, and 80, none of the fourteen words appear at all. On page 81 only two of them are included (*morning* and *delight*) and none on pages 82 and 83. Then, on page 84, four of the words appear, with one word repeated twice *(embroidery, delight, dawn,* and two repetitions of *day)*. On page 85 four words are used (this time *evening, shadow, silence,* and *night).* The darker and more mysterious of the words surface here as the pace begins to quicken. On page 86 we see seven of the words, all on the suspenseful first half of the page.

> "The weather was gloomy and *cold* that evening—it was unlike a *night* in Spain. Its *chill* appeared to extend to the party. Ines sat and worked in *silence*—the children, collected at the window, communicated in *whispers.* (3:86) (Italics added)

(One other word—*day*—appears farther down on the page.) The correlation between these words and rising action is even more obvious in one of the most exciting sections of the novel, Isidora's escape with Melmoth, their flight through the forest, and their hurried and clandestine marriage in the woods. Maturin speaks of "the speed with which they seemed to fly" and explains that Isidora "was

borne on with a kind of supernatural velocity," a velocity of which the pace of this entire section partakes. On page 54 (vol. 2), the point of greatest tension, the words appear eleven times—*whispers, wilder, paths, light, night* (repeated three times), *dark* (repeated twice), *cold* (repeated twice), and both the hour and season are noted. On the following page, where Isidora and Melmoth pause to catch their breath, the words are repeated five times—*chilling, dark* (repeated twice), *lighting,* and *night*—and the seasons are referred to three times. (The world *pale* also occurs.) On page 56 the words appear eight times—*darkness, night* (repeated three times), *path* (repeated twice), *wild, whisper,* and *silent;* a season is mentioned once, and the words *narrow* and *shallow* are included. By page 57, where the action begins to subside a little since Melmoth and Isidora have now successfully fled deep within the forest, the words appear seven times—*darkness, silence, chills, night* (repeated twice), *shadows,* and *wildly.* Although the marriage has not yet taken place, the escape has been completed by the next page, and union is inevitable. On this page only one of the fourteen words occurs (*wild*).

By constantly noting the alternation of night and day, morning and evening, summer and fall, winter and spring, Maturin interjects the supernatural into the flow of the seasons; the forces of eternity are reinserted into time. The recurring reference to time by such phrases as "each hour," "within hours," "hourly," "the following evening," or "the next morning" creates the sense of an unbroken sequence free of gaps; all time appears to be filled up with thought and action, and this sense of fullness contributes to an undiluted intensity. At some points an overlapping of time compounds the density of reality. As one series of events progresses from day to night and season to season, a second series occurs simultaneously. A certain thickness of events as well as a length of incidents results.

"On the Following Day"

Night | "On the Same Day" | "On the Same Day" | Day

Night | | | Day

"On the Following Day"

This joint expansion in the sequence of events (→) and in their depth (↓) intensifies the Gothic reality by packing it with thought and action, creating a multileveled progression.

Maturin speaks directly in his novel of the unbearable intensity created by unrelieved repetition. "This stiff and stern monotony of the parterre, where even the productions of nature held their pace as if under the restraint of duty, forced the conviction of its *unnatural regularity*, on her eye and soul, and she turned to heaven for relief" (1:3) (italics added). Similarly, Maturin comments on the maddening effect of the "severe restraint and regularity of the household," and John Melmoth wishes "the dash of the rain less monotonous." The unchanging quality of Isidora's life

drives her to break the bonds of that regularity and throw herself into the unpredictable. As in the famous Chinese water torture, unrelieved repetition can induce madness.

Maturin speaks of incessant recurrence as a reminder of the grief of eternity. With reference to waves upon the shore, "Their restless monotony of repetition corresponds with the beatings of a heart which asks its destiny from the phenomena of nature, and feels the answer is–'misery' " (2:249). The Gothic suggestion of eternity through repetition is articulated here in its tragic human context. Maturin extols organic irregularity, contrasting nature and religion. He concludes that the virtues of nature are deemed vices in a convent, comparing the rigid schedule in the convent with the varied repetitions of nature. Those characters condemned by the convent are termed "irregular" by the church, yet they are depicted as laudable in the novel. Irregularity becomes an ideal. When Maturin and other Gothic writers speak of regularity as unnatural, they affirm a vision of existence that is essentially unordered.

Convolution and repetition imply expansion in space and time; the Gothic line appears endless in its twisted course, and ceaseless repetition suggests the eternal. Maturin's orientation in *Melmoth the Wanderer* also incorporates an expansion through his use of extremity, intensity, and contrast. Melmoth himself is an extreme character. "Anything of intense and terrible resolution–of feeling or action in extremity–made harmony with the powerful but discorded chords of his soul." The word *extremity* itself is overused in the novel. "Driven to extremity myself, I felt a kind of pride in driving others to it in return" (spoken by Alonzo). "God, aid me in this extremity" (spoken by Isidora). "The very extremity of their grief . . ." (with reference to Walberg and Ines). "The extremity of human agony" (with reference to Everhard). "Extreme calamity" and the "extremities of despair and dissolution" (with reference to the types of

desperation that attract Melmoth). "Desert me not in this extremity" (spoken by Donna Clara). The words *intense, expansive, enlarged, eternal, perpetual, unfathomable,* and *inextinguishable* are also recurrent. Melmoth describes his great angelic sin, the first mortal sin, as the pride of intellectual glorying, "a boundless aspiration after forbidden knowledge," a boundlessness pursued in space and time, thought and action in all Gothic art.

A contrast of extremes appears throughout the novel in every conceivable area. In characterization one person clashes with the next: one is eternal fire beside another of untrodden freshness, one the oasis in the desert of the next. When one is apathetic the next is fanatic; when one is experienced the other naive. Ines whispers while Walberg shouts, or Alonzo is lonely and timid while his brother Juan is fearless and independent. Always we see the "union of the lowest with the highest" (2:28). Maturin constantly points out these contrasts as well as drawing them. Within themselves the characters experience clashes between their pasts and presents or between incompatible patterns of behavior. They switch abruptly from atrocity to levity, from guilt to light-mindedness, from wildness to calm. Often a character's behavior will contradict his thoughts. Isidora, for example, is externally weak while internally energized. The characters' states of mind are often self-contradictory. Walberg feels a stern and fearful joy, Ines knows grief combined with horror, and Everhard is both wild and feeble.

Contrasts in setting are oppressively constant within single descriptions, as in "dark and brilliant light," or between adjacent settings: mountains beside moors, narrow entries next to spacious openings, the splendid ceremonies at Mortimer Castle versus the frugal fare at Yorkshire Cottage, or "the relics of art forever decaying–the productions of nature forever renewed" (1:43). Maturin stresses an

absence of intermediaries, "The contrast was very strong, there was no connecting link, no graduated medium—you passed at once from the first and fairest flowers of spring, to the withered and root-less barrenness of winter" (3:88). Thematic contrasts seem equally endless—the rigidity of life and the hopefulness of death, the silence of humanity and the eloquence of the grave, the artificial and the natural, poverty and wealth, expectation and contempt, dependence and independence. Inaccurate expectations prevail since they render reality at a greater distance from the ill-conceived forecast. Paradoxes of the human condition are similarly relished, such as the inspiration a painter conveys in his depiction of human agony (3:120). The artistic merger of the aesthetic and the repulsive delights the Gothic search for the incompatible, for that which misfits yet is forced into proximity. All the exaggerated polarities, the conferences of contradictions, form a terrible momentary association in Gothic expression, stretching the perimeters of possibility and then combining them in a double fission and fusion.

Turning from stylistic principles to the thematic content of the novel, we find that love and religion are the central topics that unite the disparate narratives. Isidora's conversion to Catholicism and the reactions of her lover, Melmoth, emphasize the restrictions within Christianity. Isidora first meets Melmoth, the representative of the Gothic ideal, on a lush, deserted island where she was raised after a tragic shipwreck. Isidora is later rescued from the island, returned to her family, and educated as a good, Spanish Catholic. Her father describes the ideal Catholic maiden as formal, essential, venial, and indispensable, a bastion of discretion and reserve. After Isidora's conversion to Catholicism, Melmoth chides her: "You are now a baptized daughter of the Catholic church,—the member of a civilized community,—the child of a family that knows not the

stranger." Christianity no longer remembers the time when
its ancestors were strangers in the land of Egypt and wan-
derers in the desert or when its initial drives for freedom
and love (and for incest and blood) threatened the structure
of the family and society. Melmoth accuses religion of cast-
ing out the stranger within the community and within the
self, of condemning the random reality of the wanderer in
favor of the programmed restriction of a set path, a directed
course of achievement. Melmoth is the stranger not tied by
familial obligations, whose wild, erratic course resembles
the Gothic line. The religious denial of nature and emotion
and the substitution of formal behavior and ritual are con-
demned from the Gothic perspective. Maturin comments:

> The worthy priest piqued himself on his orthodoxy of all
> matters of belief and form enjoined by the Catholic
> church; and moreover, had acquired a kind of monastic
> apathy, of sanctified stoicism, which priests sometimes
> imagine is the conquest of grace over the rebellion of
> nature, when it is merely the result of a profession that
> denies nature its objects and its ties. (3:110)

Nevertheless, Melmoth sincerely states, "I venerate all
faiths—alike, I hold all religious rites pretty much in the
same respect, I believe it all—I know it all." All the beliefs of
religion, all the extensions of reality that stretch the mind to
comprehend and accept, are part of the Gothic vision. Only
when religion begins to limit and qualify its vision, to dif-
ferentiate itself from other religions and step back from the
Gothic *all,* does Gothicism object. In this sense Gothicism is a
thoroughgoing mystical pantheism wherein everything is
expanded, everything is God.

In another volume of the novel, Ines (a Catholic convert
to Protestantism) tells her Protestant husband: "you first
taught me that the doctrines of salvation are to be found
alone in the holy scriptures." The Protestant assertion that it

is within every person's power (and not just within the official church) to interpret the Bible is taken a few steps further in the Gothic claim that people can absorb the power of God or the curse of Satan. With reference to the devil, Melmoth says, "Enemy of mankind! ... Alas! how absurdly is the title bestowed on the great angelic chief. ... What enemy has man so deadly as himself?"

The absolute distinction between the Devil and God is minimized in the character of Melmoth, who is a combined devil-god, and other characters in the novel are similarly represented as both godly and demonic (such as Alonzo's companion, who is dreaded as a demon yet invoked as a god.) Melmoth is associated with a number of different biblical characters. He has the brand on his brow, linking him with Cain, the first murderer, condemned to wander the earth for his crime of blood, yet he is also cast as Adam after the Fall, who has "eaten of the fruit of the interdicted tree ... and [been] sent to wander mid worlds of barrenness and curse for ever and ever." (Notice the similarities between the vampire's curse and that of both Cain and Adam. In exchange for his blood thirst, the vampire too is condemned to wander the earth forever.) Melmoth is depicted as a devil in that he is the "negative to the appeal made in the name of all that is holy among Christians," his eyes seem "lit by an infernal fire," and he approaches desperate individuals in their hour of extremity, promising deliverance if they exchange positions with him (those people bitten by vampires also become vampires themselves). Yet there are aspects of Melmoth that suggest a god: his eyes are described as having a supernatural luster, he is an object of both terror and wonder, his existence is beyond the period allotted to mortal man, and he can pass over space without disturbance or delay, visiting remote regions with the swiftness of thought. Despite his supernatural powers, Melmoth has the form and figure of a living man,

and in the end, when he dies, the supernatural luster goes out of his eyes. In that Melmoth is part mortal and part divine, and in that he addresses himself to guilt and suffering, he approximates a Christ figure. Like Christ he dies a terrible death, he offers salvation to those who suffer from pain and guilt, and he promises a form of eternal life. In the characteristic Gothic inclusion, Melmoth partakes of a god, a Christ, an Adam, a Cain, a vampire, and a devil.

Religion and love are closely associated in Maturin's novel as profound, perilous absorptions to which the soul is bound in absolute servitude. In both love and religion the devotee pauses on the brink of an abyss in which all energies, passions, and powers are immersed; Maturin speaks of "that pause, while the balance is trembling (and we tremble with it) between God and man" (3:18). Gothicism criticizes religion for its retreat from the edge of the abyss and for its choice of God over man. Isidora is torn between her religion and her love for Melmoth but ultimately chooses in favor of love. "I loved you before I was a Christian. They have changed my creed—but they never can change my heart ... from the grated window of my Christian prison,—I utter the same sounds. What can woman, what can man, in all the boasted superiority of his character and feeling, (which I have learned only since I became a Christian, or an European), do more?" (3:14). Melmoth returns that although love may triumph over the restraints of religion, love of *him* (of the Gothic vision) is precluded by religion. The sections of the novel that deal with the Inquisition also juxtapose religion and love, here contrasting religious vanity and cruelty with selfless, loving generosity.

A transition from religious awe to secular love may be a general historical trend that Gothicism encourages. In Christianity we see an increased concentration on a God of love that is later replaced by a secular romanticism in

popular culture, by human love as a mystical salvation. Love becomes a type of religious experience often described in religious language.

> I loved you because you were my first–the sole connecting link between the human world and my heart,–the being who brought me acquainted with that wondrous instrument that lay unknown and untouched within me, and whose chords, as long as they vibrate, will disdain to obey any touch but that of their *first mover* (here and after)–because your image is mixed in my imagination with all the *glories of nature*–because your voice, when I heard it first, was something in accordance with the murmer of the ocean, and the music of the stars. And still its tones recall the *unimaginable blessedness* of those scenes where first I heard it, and still I listen to it like an exile who hears the music of his native country in a land that is far off. (3:35) (Italics added)

At other points Maturin describes love as the communion with the deity that man had before the Fall. Love is a crucial factor in the Gothic expansion because of the magnification it produces in the perception of the self and the loved one. The beloved is everything to the lover, "that eye whose light alone, to her intoxicated gaze, contains all judgment, all taste, all feeling" (3:8). At the same time the lover cultivates an expanded sense of his or her own importance in "hope of magnifying himself in the eyes of him she loved" (3:5). This magnification is not constant, according to Maturin, and is instead contrasted by opposite feelings. That first bright hour of excitement is followed by humiliation. "Then we think we never can display enough of talent, of imagination, of all that can interest, of all that can dazzle" (3:6). The tininess of the self compared to the immensity of the other is just the sort of effect that is produced within the Gothic cathedral. Following this sense of humiliation, a second sense of self-aggrandizement proceeds as we again "glorify

ourselves, that we may be enabled to render back the glory to him from whom we received it" (3:6). A parallel can be seen here to religious humiliation in the face of God's perfection followed by a reglorification as God's creation. "To love," Melmoth states, "is to live in an existence of perpetual contradictions." All existence becomes dominated by the overwhelming contrast between presence and absence.

To the extent that nonlovers do not share this overwhelming sense of presence and absence and to the extent that these contrasting states are mental products of the emotions, love represents an inturning to the world within the self. Melmoth explains: "To love, beautiful Isidora, is to live in a world of the heart's own creation." Gothicism, in literature and art, seeks to create a simultaneous inner and outer expansion, and love promotes the inner axis of this expansion. Generally, in this novel and others, the inner expansion is psychological while the outer is supernatural. Maturin's metaphors mirror this inward/outward contrast, so often leading the reader "from the glow of the planet to the glory of a mortal eye." Such phrases as "either in her outward demeanor, or inward mind" (3:41) are heavily used.

On a mythic level the novel *Melmoth the Wanderer* reenacts man's banishment from the Garden of Eden and his fall from grace. Hubris is really Melmoth's sin; he seeks to become God and is duly punished. In prototypic Gothic fashion, Melmoth pursues the forbidden in service of greater knowledge and experience. After Melmoth has "eaten of the fruit of the interdicted tree," he is sent to wander amid worlds of barrenness and curse. Ultimately, though, his punishment is death; after one hundred and fifty years of wandering, he dies and descends into hell.

In Maturin's version of the Fall, a Gothic attempt has been made to increase suspense and extend that moment on the

edge of damnation. Melmoth's fate is not entirely sealed, since he can escape his punishment by finding someone to change places with him. In this respect Melmoth is seeking a Christ to atone vicariously for him. The entire story is poised on the brink of the abyss. A space has been created between the banishment from the garden and the fall from grace, and the novel takes place between that banishment and fall. Isidora and Melmoth look back upon the paradise island they have left, and at the end of the novel (no savior having materialized) Melmoth falls from a precipice into the boiling waters of hell.

The island paradise that Isidora and Melmoth remember was located at the mouth of a river. Isidora arrived there when she was just an infant, and she grew up amidst its bounties as "the beautiful daughter of nature, feeding on fruits . . . inhaling the harmonies of heaven–and repeating to herself a few Christian words her nurse had taught her, in answer to . . . the stream whose waves murmured in accordance to the pure and holy music of her unearthly heart."

In this novel there are two gardens and two expulsions rather than one. After Isidora is rescued from the island, she is taken to her home in Spain, where she spends much of her time in the garden. Melmoth secretly visits her there, and when Isidora and Melmoth fall in love, the garden begins to remind her of the earlier island paradise. As is later explained, love "is like man before the fall, inhaling the odors of paradise, and enjoying the communion of the Deity" (3:284). When Isidora and Melmoth decide to consummate their forbidden marriage, they are forced to flee from the garden. Isidora escapes through a window left open behind her, and together they climb a steep hill, the water from a stream murmuring below them. During the descent that follows, Isidora hears something falling from the precipice into the water, which "swallows" the fallen morsel with great "relish." She suspects that the falling

object is a corpse. (This fall into cannibalistic waters is then repeated at the end of the novel in Melmoth's death.) Isidora returns to the garden after her marriage, with the understanding that Melmoth will rescue her before the hour of her impending wedding. (She has been promised to a respectable nobleman.) When Melmoth leaves this garden a second time, after his aborted attempt to rescue Isidora and his murder of her brother, he is described thus: "The mark was on his brow. . . . Every sword was in its sheath as Melmoth quitted the garden. 'Leave him to God' was the universal exclamation. . . . 'He will certainly be damned.' " The original banishment from the garden paradise has been reenacted in the garden in Spain, and even in Spain the first escape from the garden (in order to marry) prefigures the second expulsion. The Cain and Abel myth has been wedded to the Garden of Eden myth in that both sexual love and murder are the results of the forbidden fruit and the cause of expulsion. In that the garden in Spain is less of a paradise than was the paradise island, Maturin presents the reader with a progression of expulsions en route to hell.

At the end of the novel this progression is reiterated. Melmoth the Wanderer has been awaiting the hour of his death in a small room. When John Melmoth and Moncada come to see him there, they discover that he has disappeared through a small door opposite the one through which they entered. Melmoth has passed through the little door to a staircase leading to another door which opens upon a garden path leading to a broken fence and a heathy field spreading halfway up a rock whose summit overlooks the sea. (Melmoth describes the first stage of love as a garden paradise and the second stage as toil "amid the briar and the thistle.") Melmoth passes from the room to the garden to the heath through a succession of doors. On the most basic level, these progressive exits represent the

expulsion from the womb, from the kindergarten of child-hood innocence, from the garden of first love, and finally from life itself. In the end Melmoth returns to the sea, but rather than a womb of comfort, he confronts a boiling hell.

Melmoth's expulsion from life mirrors Isidora's expulsion from the garden (the open doors and windows, the garden and heath, the ascent and descent), and both expulsions recall the original banishment from the island paradise with its murmuring river. Melmoth's final fall is the consequence of his original exile.

The passage through successive openings, like the narrators within narrations and tales within tales, pierces reality. The doors within doors that Melmoth opens just before his ascent are diagrammed here.

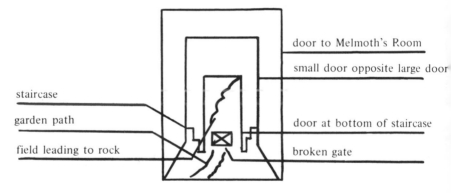

A spatial and mythic penetration complement each other.

In Melmoth's dream of his death, he stands on the ridge of the infernal precipice looking down upon the blazing ocean from which burning spray rises. On every wave floats an agonizing soul. Melmoth is flung down from the precipice, but he becomes caught midway on a crag. There he totters and looks upward, "but the upper air (for there was no heaven) showed only blackness unshadowed and

impenetrable." He then realizes that a gigantic hand holds him suspended above the burning waters while another points to a dial indicating one hundred and fifty years. Melmoth shrieks and falls into the burning sea just as Stanton, Walberg, Elinor, Mortimer, Isidora, and Moncada all pass him in their ascent. Melmoth then awakens from his dream, but shortly afterwards, when John and Moncada follow him through the little doors and then up the precipice, all that remains is his handkerchief caught on a rock overlooking the sea. The reader is left to think that Melmoth has drowned in the hell of his dream.

The many expulsions in the novel contribute to the Gothic sense of expansion. The birth trauma involves an initial constriction of space as the baby passes through a tiny opening and than a sudden, overwhelming enlargement in the scope and range of the surrounding reality. The limited enclosure of the womb gives way to the limitless outside world, the limited temperatures and tactile textures to a broad range of sensations. The lush paradise island fed by its umbilical river and surrounded by the amniotic waters of the sea is the first womb from which Melmoth and Isidora are expelled. They are later driven from the garden of home and security. Melmoth's final passage from his womblike room through a tiny door and down a garden path reenacts this trauma, as does his final expulsion from life. In death he is no longer limited by body, identity, space, or time. The shock of the extreme change, the loss of security, and the expansion of birth are the prototypic experiences that mark the Gothic endeavor.

Maturin depicts paradise as the realm of containment, satisfaction, stability, and organic rhythm. Paradise is secure and comforting, enclosed, defined, and tranquil. Yet Gothicism rejects celestial boredom for the excitement of change and pain. Maturin delineates the two alternatives, as the Gothic sensibility perceives them, in Elinor's unsuccessful attempt to resign herself to the religious life.

She saw a being far inferior to herself in mental power,–of feelings that hardly deserved the name,–tranquil. ... Alas, she did not know, that the heartless and unimaginative are those alone who entitle themselves to the comforts of life, and who can alone enjoy them. ... So much the worse for them,–the being reduced to providing for the necessities of human life, and being satisfied when that provision is made ... beyond that, all is the dream of insanity, or the agony of disappointment. (3:217)

Maturin characterizes the stable yet unimaginative existence as "the dull and dusky winter's day, whose gloom, if it never abates, never increases" and the dynamic, engaging life as "the glorious fierceness of the summer's day, whose sun sets amid purple and gold,– while, panting under its parting beams, we see the clouds collecting in the darkening East, and view the armies of heaven on their march, whose thunders are to break our rest, and whose lightnings may crumble us to ashes." Gothicism chooses the glorious fierceness with its dreams and insanity, agony and disappointment. It seeks to return to the chaos before creation, before division and distinction, appropriation and prohibition. The Gothic hero devours the forbidden apple not only because he is willing to pay for his freedom but also because he savors the smell of death.

NOTES

1. Charles Robert Maturin, *Melmoth the Wanderer* (London: Richard Bentley and Son, 1892), 3:29.

2. I say "unusual frequency" in that such words as *the, and,* and *a* are obviously repeated more often, yet their repetition is not unusual in English. The constant repetition of the words I have chosen does strike the reader as unusual.

3. A series of light-associated words, such as *bright, gleam, glow, illuminate,* and *irradiate* are also quite frequent, and in their combined frequency they would fall between *light* and *silence*.

[5]
Uncle Silas
by J. S. LeFanu

THE twisted line so outstanding in *Melmoth the Wanderer* is also present in *Uncle Silas*. This novel too has its share of winding rills and rivers, spiral staircases, gnarled hands, and tangled hair. LeFanu describes "ivied rocks and twisted roots" and pathways "devious among the stems of old trees ... interlaced and groined with their knotted roots." Bartram-Haugh, the setting for much of the novel, is marked by "sinister lines of circumvallation," the prominent vein in Uncle Silas's forehead stands out "as a knotted blue cord," and the devil is described as stealthily approaching the citadel of his heart "with many zig-zags and parallels." Financial difficulties are termed "unhappy entanglements," and from the depth of his despair Uncle Silas cries out "I am entangled—lost." LeFanu, like Maturin, leads his readers through the diffuse and tangled narrative that his characters relate. However, despite the many instances of twisted forms, elongation rather than convolution is the more dominant configuration in this novel. Tense, linear forms dominate character descriptions, setting, imagery, and word choice, the preponderance of these forms being compounded by their repetition. The length of a particular object is often reemphasized every time it is mentioned. The result is a general feeling of attenuation throughout the novel.

An unusual number of the major characters are tall and thin: Maud, the main character, is tall; her father, Austin Ruthyn, tall and slight; Monica Knollys, Maud's cousin, is "rather tall, by no means stout"; Madame de la Rougierre, Maud's governess, is very tall; Uncle Silas is "straight, thin, and long"; Dr. Bryerly is tall and lean, a "lank high-priest"; the fortune teller is tall and lithe; Rev. Fairfield appears thin; the sly coachman is also thin; Sarah Matilda, Dudley Ruthyn's wife, is "decidedly thinner"; Meg, the miller's daughter, though "neither tall nor stout" is "taller than she looked at a distance"; Mr. Clarke has "very high shoulders"; the imaginary link-man is lank; the mysterious figure encountered by Maud during her walks is tall and slim; and the strange visitor who comes to Bartram-Haugh during the night is very tall. In addition to the elongation of height, the extension of limbs, of other parts of the body, and of the accessories to person is stressed. Long, thin hands and fingers are unusually common among the characters, and attention is constantly drawn to the extremities of the body. Madame Rougierre has long hands and arms, a great long nose, hollow cheeks, and long, lank legs; Maud has long hands and long lashes; Mrs. Rusk, the housekeeper, displays thin hands and a lean face; Doctor Bryerly's hands are long and hard; the fortune teller has slim hands; and the Rev. Fairfield has a high and thin nose. Uncle Silas is variously described as extending a thin, white hand and long, thin arms; he also has a high, thin forehead, long white hair hanging toward the ground, and a thin voice. The length of Uncle Silas's hands, fingers, arms, or hair is mentioned nearly every time he appears. (There are in fact sixty-three descriptions of fingers in the novel.) Mr. Danvers rides a tall, gray horse; Mr. Clarke puffs a cigar straight up into the air—the examples are certainly bountiful. In setting, length is likewise ever-present. The first scene in the novel takes place in a long room with tall trees looming outside the

window. Austin Ruthyn's library, a focal point in the novel, is a long, narrow room with two tall, slim windows at the far end. Tall trees repeatedly appear, and they become progressively closer and taller as the story proceeds. Long, narrow passages and hallways characterize both Knowl and Bartram-Haugh, and outdoors the characters seem always to be walking down long, narrow pathways.

The word *long* itself and different forms of the word, including the verb *to long*, the adverb *along*, the expression *at length*, and the adjectives *longer* and *longest*, occur 292 times in the novel. The word *long* is even substituted as an adjective for height. For example, Monica Knollys tells Maud that she has not seen her since she was "no longer than the paper-knife," and Milly Ruthyn remarks that Maud is "a half inch longer than me." The word *height*, forms of the adjective *high*, and the adverb *highly* are emphasized, as are the verbs *to raise* and *to rise*. These words invoke a sense of vertical extension. On a more abstract level, there is a predilection for long words in the novel, words that are often inappropriately long, and thus more prominent, for their context or speaker. This tendency occurs in many Gothic novels, particularly, for example, in the works of Edgar Allan Poe. LeFanu uses such phrases as "in the excess of her conciliatory paroxysm," "contumacious appetite," "incomprehensible roulades of lamentation," or "baleful effulgence" for their sense of the exotic and extraordinary but also for their sheer length.

Elongation in the words and shapes in Gothic literature is directly related to the elongation in Gothic architecture, to the great height of the cathedral with its soaring pillars and the pointed arches that express vertical extension as the eye is led upward toward the point of the arch. The entire structure of Gothic architecture encourages movement along the extended nave and both up and down the attached columns and ribs. The elongated forms in the

Gothic novel similarly encourage movement and transition. Both H. P. Lovecraft and Tzvetan Todorov have noted the importance of incident in Gothic literature, Todorov explaining that the disturbance of narrative balance to create disequilibrium produces a disruption in stable situations and promotes dynamic development.[1] The transgression of laws in the Gothic novel (of natural law through supernatural intervention, of moral law through crime, or of social mores through abnormal behavior) further disturbs equilibrium. Within characterization, moodiness, anxiety, and restlessness all indicate emotional instability, just as the recurrent word *longing* in *Uncle Silas* indicates a lack of fulfillment and an inclination to approach the source of desire. LeFanu depicts abrupt transitions of mood on the part of Madame Rougierre, his most Gothic character, and an overall sense of transition in the novel results from the disequilibrium caused by the death of Austin Ruthyn, the expulsion of Maud from Knowl, her move to Bartram-Haugh, her kidnapping and supposed journey to Paris, and finally her return to the attic room where she is scheduled to be murdered.

In conjunction with elongation, asymmetry is evident in this novel. Both the shape of rooms and the behavior of characters are described as irregular, and, like Maturin, LeFanu explores the way unrelieved regularity provokes irregularity. At the outset of the novel, life at Knowl is depicted as silent, secluded, and monotonous; even Maud's contact with her father is marked by regular intervals. A supersensitivity soon develops to the slightest deviation from accustomed routine, and a taste for disruption is thereby cultivated.

The great size and height in Gothic architecture is paralleled by an enlargement of scale in the novel *Uncle Silas*. Madame Rougierre "was on an unusually large scale, a circumstance which made some of her traits more startling,

and altogether rendered her, in her strange way, more awful in the eyes of a nervous child." Uncle Silas, a tremendous figure, is a man of great talents, great faults, and great wrongs. The image of large hands haunts this novel, Madame Rougierre's, Uncle Silas's, Dr. Bryerly's, Dudley Ruthyn's, and Old Wyat's, among others. The sense of magnification is inescapable, amplifying a frightening reality and bringing us closer to it. The ultimate enlargement, to infinite proportions, is even evoked. In Dr. Bryerly's words:

> Remember, then, that when you fancy yourself alone and wrapt in darkness you stand in fact, in the center of a theatre, as wide as the starry floor of heaven, with an audience, whom no man can number.[2]

Much attention is focused on hands of all sizes; in fact, there is not a single character whose hands are not mentioned at least once. People are constantly fiddling with their fingers or staring at them, the positions of their hands being carefully detailed. When hands are sunburned, when they are chapped or smooth, it is noted, and personality traits are often revealed by hands, a charitable person having "a princely hand," a practical one a "hard, lean grasp." Figuratively, we hear of the "hands of heaven," and of angels "in their hands they will bear us up." The central crime in the novel is Uncle Silas's attempt to take fate into his own hands, and after the murder, Dudley's hands are covered with blood. Gothic villains are always guilty of excessive aggression, of self-assertion and self-expansion in their pursuit of power. They seek a Mephistophelian mastery of the world, a domination through personal agency. Their evil is not a passive one—they are condemned for what they do rather than what they are. The satanic is infective; vampires create more

vampires. In that hands are the medium of manual mastery, they symbolize the competent, meddling Gothic tyrant who manipulates others for his own ends.

Because power begins with knowledge, a thirst for thought is the beginning of crime. Like Maturin, LeFanu evokes the image of the Fall in the Garden of Eden as the sign of a hunger for power.

> Why is it that this form of ambition–curiosity–which entered into the temptation of our first parent, is so specially hard to resist? Knowledge is power–and power of one sort or another is the secret lust of human souls; and here is, beside the sense of exploration, the undefinable interest of a story, and above all, something forbidden to stimulate the appetite. (P. 11)

With these words LeFanu concludes the chapter he entitles "Uncle Silas."

The presence of extremes and their juxtaposition is evident in *Uncle Silas* as it was in *Melmoth the Wanderer.* Here too characters cry out "help me in this extremity," here too the happiest fire and cheerful candles glitter inside while the dark storm rages outside, and once again contradictory states are drawn, such as the wedding of awe and apathy. Descriptions in *Uncle Silas* have been greatly simplified; size and color prevail, and gradations of tone are eliminated. Not only are all the characters either tall or short, but also they seem to be photographed in black and white. (Even minor characters who are not tall are invariably short and stout: Pegtop is a squat, broad figure who wears short trousers and gives a "short shake" of his hair when he walks; his daughter has a "short shooting coat"; Dudley Ruthyn smokes a short pipe; and cousin Milly is a plump girl with fattish legs who wears unusually short petticoats and skirts.) Those characters who are categorized as long generally have contrasting short aspects. For example, a man

described as tall and lean has a "short visage" and gives a "short nod." No one and nothing in the novel ever appears to be medium in height. Moderation is everywhere avoided, even in physique.

With the exception of a few important appearances of red and an occasional tinge of yellow, only the colors black and white are used in the novel. Often black and white are shown beside each other, as in the strangers encountered on the road to Knowl; not only is one tall and thin and the other short and fat, but one wears black and the other white. Madame Rougierre who has very white skin and wears white clothes, appearing "nearly white under the moon," has black, thick hair, "hair too thick and black, perhaps, to correspond quite naturally with her bleached and sallow skin." Uncle Silas has black eyebrows, yet all the rest of his hair is white. He dresses in a black suit with a black velvet tunic, wears a snowy white shirt, and extends a thin, white hand. LeFanu calls him "an apparition, drawn as it seemed in black and white." Dr. Bryerly wears a black coat with a white choker and has black hair, dark lustrous eyes, a swarthy face, dark lashes, and very white teeth, and Milly Ruthyn wears black boots, a black cotton dress, and white stockings. After Austin Ruthyn has died, he appears draped in black and very pale. The stranger who comes to the house after Austin's death wears black clothes and a white cravat. Captain Oakley remarks that he loves white and black houses, and he describes Knowl in this very way. At times black and white are not found together in the same description, but one scene will be drawn entirely in black and the next in white. Technicolor with its fine distinctions is not the Gothic way. More effective, like the simplified, ever stereotyped characters, are the hard outlines, the sharp edges of the monochromatic—all colors combined create black, and their absence is white.

Black, of course, symbolizes death in the novel, and LeFanu explicitly states the association. Dr. Bryerly looks "angular, ungainly, in the black coat that fitted little better than a coffin," and Maud meets death as a face draped in black. But white too is the color of death; we see Uncle Silas, "his figure straight, thin, and long, dressed in a white dressing-gown, looking like a corpse 'laid out' in the bed." Much white is used in connection with Uncle Silas: his house has a white front and a white stone way leading to it, the trees around the house have bleaching trunks and limbs, all the furniture has been painted white, and nearly every time Uncle Silas appears, his long, white hair, his pale complexion, the whites of his eyes, or his white hands are mentioned. He even requests his white drops in a thin voice. Other characters similarly blanch in the novel: Austin Ruthyn's face is "sometimes white and sharp as ivory," Milly Ruthyn wishes her hands whiter, a frightened Maud looks as "white as that handkerchief," Dykes's face becomes white with anger, Mary Quince has a white face, Madame Rougierre white lips, the Miller's daughter white eyes and teeth, and other characters turn white with fear. White suggests the absence of life as black suggests its destruction. There is no symbolic life option in this juxtaposition—black and white do not symbolize life and death but both suggest the lifeless; one is annihiliation and the other sterility.

The plot of the novel revolves almost exclusively around death. The story begins with an old man, Austin Ruthyn, whose young wife has died and whose daughter, Maud, fears that her father too may die. Austin Ruthyn does die, and Maud is sent to live with her Uncle, a man who once committed a murder. By the end of the story Uncle Silas and his son attempt to murder Maud, mistakenly killing Madame Rougierre.

The characters are preoccupied with death even when it is not present in reality. Well before Austin Ruthyn dies,

Maud fears his passing. She also dreams that her governess leads her in the dead of night to a locked closet where a white and malignant image of her father screams "death" in a terrible voice. In reality Madame Rougierre fantasizes about death in a playful and gruesome way. She sings to Maud of a lady who is half pig and half human, who is not of the living nor the dead, and who goes for long periods without rest and then sleeps like a corpse for a month or more. It is suggested that this pig-lady eats human flesh. When Madame Rougierre plays with Maud, she teases her: "I am Madame la Morgue—Mrs. Deadhouse. I will present you my friends, Monsieur Cadavre and Monsieur Squelette." She bluntly asks Maud, "Dont't you love the dead, cheale? . . . you shall see me die here today for half an hour, and be among them." Captain Oakley speaks of the "savouring of death unto death," Uncle Silas talks "as if the image of death was always before him . . . seemingly dozing away the dregs of his days in sight of his coffin," and the doctor explains that to take opium as Uncle Silas does is to trifle with death. Through the use of metaphor, death is introduced into settings and conversations where it would otherwise be absent. Monica Knollys comments, "I have ever so many letters to write, and my people must think I'm dead by this time." Maud remarks "truth, like murder, will out some day" or "my heart swelled and fluttered up to my lips, and then dropped down dead as it seemed into its place." Madame Rougierre is described as drawing her lip between her teeth: "what a deathlike and idiotic look the contortion gave her"; and Dr. Bryerly's hand seems as "brown as a mummy's."

Death is alternately portrayed as disgusting and attractive, as terrifying and alluring. After Austin Ruthyn's funeral, the details of which are meticulously examined, the characters are relieved that the repulsive and dreadful ceremony is over, yet Maud speaks later of the funereal but

glorious woods where her mother is buried, a dark visitor thinks of death as a fountain in the wilderness, and death is likened to a mother who knows what is best for her sleepy children. Death is feared or welcomed, fought or evoked, but it is never ignored, never met by indifference. It is black or white, not gray.

Religion functions in this novel, as in many Gothic novels, as a partner in the confrontation with death. Maud's reaction to her mother's death is compared to Mary's feeling at the empty sepulcher of Christ. Christianity is at points scorned as foolish or feeble in its attempt to mitigate death and suffering, at some points being accused of involvement in suffering and unmentionable crimes, but at other points hallowed as a singular stronghold against death's triumph.

> Oh, Death, King of terrors. The body quakes and the spirit faints before thee. . . . The horrible image will not be excluded. We have just the word spoken eighteen hundred years ago, and our trembling faith. And through the broken vault the gleam of the star of Bethlehem. (P. 143)

Archetypally, there is a startling similarity between the "birth into death" images in this novel and in *Melmoth the Wanderer,* despite the fact that these two works are markedly dissimilar in style, tone, location, and orientation. The garden, the ascending and descending mountain path, the narrow doorway, and the plunge from a mountain or from any height are recast in *Uncle Silas.* Maud often walks in the garden and along the paths leading out from the garden. When she takes her crucial journey to Bartram-Haugh, her ascent and descent on the long and curving mountain road is reminiscent of Melmoth's journeys. In places the mountain is so steep that Maud must get out of her carriage and scale the cliffs on foot. As she reaches the summit, the sun goes down, the mist rises, and the air becomes dark and

cold. Maud descends, entering a wilder and bolder region enveloped in shadow and inhabited by gypsies. The moon rises and begins to glimmer along the heathy moor. Elsewhere in the story, during a walk through the garden and into the forest, Maud fears that Dr. Bryerly will take her through the woods to a place of wonders and shadows where the dead are visible. Dr. Bryerly tells Maud of a journey along an airy path, ascending among mountains of fantastic height to peaks that can be approached only through the gate of death, "the door open before us in the wilderness" (p. 15). The images of the garden, of the narrow and distant gate, and of ascents and descents in a wild region with a final image of descent occur again when Maud and Madame Rougierre start off on a narrow, hilly, inclined carriage-road that is blue with shadows, traversing a wild region to which a distant gate gives entrance. Maud follows the path, descending as she goes (p. 85). Throughout the novel, the words *shadow* and *wild* appear again and again.[3]

Jung connects the images of the shadow, the narrow path, the gate, and the descent in his discussion of the collective unconscious, relating these archetypes to an initial confrontation with the self.

> The meeting with oneself is, at first, the meeting with one's own shadow. The shadow is a tight passage, a narrow door, whose painful constriction no one is spared who goes down to the deep well. But one must learn to know oneself in order to know who one is. For what comes after the door is, surprisingly enough, a boundless expanse full of unprecedented uncertainty, with apparently no inside and no outside, no above and no below, no here and no there, no mine and no thine, no good and no bad. It is the world of water, where all life floats in suspension; where the realm of the sympathetic system, the soul of everything living, begins; where I am indivisibly this *and* that; where I experience the other in myself and the other-than-myself experiences me.[4]

Jung proposes a type of all-inclusive experience, an all-embracing acceptance that leads to the compound, godly-satanic villains in Gothic novels. In Uncle Silas we see another of these Gothic characters, an "enigmatical person—martyr, angel demon" (p. 147), a union both of good and of evil, spiritual and physical, a soul other than human clothed in human flesh (p. 159), "the phantom of spiritual things immortal shown in material shape" (p. 436). The non-transcendental bias in Gothicism places the expansion within man, thus invoking a self-confrontation as described by Jung.

Jung links the garden symbol, precisely the Garden of Eden, with a mandala and a process of individuation, explaining that that contrast between desert and paradise signifies isolation as contrasted with the becoming of self.[5] This contrast of desert and garden is echoed in Dr. Bryerly's description in *Uncle Silas* of Hagar in the desert. The doctor explains to Maud, "Sooner or later, the time comes, as Hagar's eyes were opened in the wilderness, and she beheld the fountain of water, so shall each of us see the door open before us, and enter in and be refreshed." Dr. Bryerly goes on to clarify that the door to which he refers is not merely the door of self-knowledge but actually the gate of death, and the shadows that he describes as he shades his downcast eyes are the dead made visible. Maud and Dr. Bryerly sit in these shadows while Dr. Bryerly describes the airy land-scape in which Maud's mother moved along a path ascending through mountains of fantastic height. The Gothic message seems to be that when people confront themselves, their origin and their future, they ultimately confront death. Death is the basic reality in Gothicism, the source of both attraction and fear and the essential contrast against which life is defined. The specter of death haunting the Gothic quickens the novels and our attraction to them while intensifying life by contrast.

In Jungian terms, Gothicism plunges into the chaotic capriciousness of the anima, caught and entangled in aimless experience against which the categories of the intellect prove ineffective.

Human interpretation fails, for a turbulent life-situation has arisen that refuses to fit any of the traditional meanings assigned to it. It is a moment of collapse. We sink into a final depth—Apuleius calls it "a kind of voluntary death." It is a surrender of our own powers not artificially willed but forced upon us by nature; not a voluntary submission and humiliation decked in moral garb but an utter and unmistakable defeat crowned with the panic fear of demoralization.[6]

The archetype of meaning, which Jung describes as appearing at this point, does not triumph in Gothicism nor does it accompany the anima. Rather, the anima, the archetype of life itself, intoxicates the Gothic hero and plunges him into a chaotic intensity leading to death.

NOTES

1. Tzvetan Todorov, *The Fantastic: A Structural Appraoch to a Literary Genre* (Cleveland, Ohio: Case Western Reserve University Press, 1973), pp. 163-65.

2. J. S. LeFanu, *Uncle Silas* (New York: Dover Publications, Inc., 1966), pp. 125-26.

3. The word *wild* occurs 76 times in the novel and the word *shadow* 54 times.

4. Carl Gustave Jung, *The Archetypes and the Collective Unconscious* (Princeton, N. J.: Princeton University Press, 1969), p. 22.

5. Ibid., p. 35.

6. Ibid., p. 32.

[6]
"The Haunters and the Haunted" or "The House and the Brain" by Edward Bulwer-Lytton

THE short story "The Haunters and the Haunted" or "The House and the Brain"[1] is lighter and more casual in tone than either *Melmoth the Wanderer* or *Uncle Silas*. The central character in this story is not inextricably enmeshed in a threatening reality that endangers his well-being or his life but is drawn to his Gothic encounter out of intellectual curiosity, yet the visions and dreams he experiences are remarkably similar to those presented by Maturin and LeFanu. The story begins with the narrator's account of a conversation in which his friend informs him, "Fancy! Since we last met I have discovered a haunted house in the midst of London." The narrator replies, "Really haunted? and by what–ghosts?" The reader is struck by the casual though interested tone of the conversation, where a more incredulous or suspicious reaction would be expected. All that follows this conversation is designed to bring the reader to the point where the narrator began, to urge him to accept the initial extension of reality that was so casually assumed.

When asked to describe his experience in the haunted house, the friend refuses to comply for fear that he may be ridiculed as a superstitious dreamer, protesting that his affirmation must be verified firsthand by others. This

retreat from the original acceptance acknowledges a sense of implausibility and in itself renders the story more believable. The friend's insistence upon factual information begins the process of repeated validation by numerous witnesses, including the narrator, his companion, and even his dog.

The character of each witness and his experience are carefully examined in order to convey the authenticity of the report. The narrator's friend is a person so repulsed by superstition and gossip that he is even hesitant to repeat the details of what he has seen, but his wife's accounts corroborate his own, as do the testimonies of the other tenants who previously rented the house. Finally, the narrator himself, a frank, business-minded, clear-headed man, stays overnight in the building. He describes himself as a person free from prejudice who values healthfulness and practical living as antidotes to superstitious fancy, and he even has professional training pertaining to unusual phenomena, having worked on experiments with the marvelous. Bulwer-Lytton creates the illusion of experimental verification and scientific objectivity by the insistence on firsthand observation, by the presentation of similar results by numerous observers, and by the depiction of intelligent, reliable witnesses who shun inaccuracy or exaggeration. The extraordinary or transcendent quality associated with the haunted is embedded in the rational and practical context of business and science.

The narrator refers to the owner of the house as Mr. J— and the address as No.— on 6— Street, indicating that he wishes to withhold the true identity and location of the house. Since the story is presumed to have some basis in fact, the names appear to be disguised while the story would be true. The illusion of factual accuracy is enhanced by scientific or pseudo-scientific terminology, such as the use of the word *eidolon* for a phantom of the dead. When spirits

are shown to inhabit the house, they are explained as agencies conveyed as if by electric wires from one brain to another, and phantoms are defined as aspects of hypnosis applied to inanimate objects or the dead. The power to mesmerize, as is termed the ability to alter reality through the exercise of the mind, is not seen as against nature but within it; as the narrator explicitly states:

> "Now my theory is that the supernatural is only something in the laws of nature of which we have been hitherto ignorant. Therefore, if a ghost rise before me, I have not the right to say, 'So, then, the supernatural is possible,' but rather, 'So, then, the apparition of a ghost is, contrary to received opinion, within the laws of nature, namely not supernatural."[2]

The assumption throughout the story is that forces "within the reach of science may produce effects like those ascribed of old to evil magic" (p. 317). The supernatural has in effect been defined out of existence, only ignorance creating an illusionary gap between the natural and the supernatural. Furthermore, miraculous and monstrous occurrences are not divine but mortal in origin. "That this brain is of immense power, that it can set matter into movement, that it is malignant and destructive, I believe" (p. 306); the brain in question is, however, unequivocally human.

Once scientific jargon has been introduced to bolster plausible explanatioons of the unknown, the realm of science is inconspicuously expanded to include the fantastic. The reader is eased into a world of fantasy clothed in the cloak of physics. Reference is made to an experiment by Paracelsus in which a flower is burned and a specter of the plant produced from the ashes of the flower. Magic and alchemy have been classified as chemistry. Gradual extensions of logic similarly occur until the illogical is included. Phantoms, for example, are explained in the following way:

"as thought is imperishable, as it leaves its stamp behind it in the natural world, so the thought of the living may have power to rouse up and revive the thoughts of the dead, such as those thoughts *were in life*." The rationality and immanence of science and logic mark all that they touch with a tinge of truth.

The incorporation of the incredible into the everyday world is revealed in the narrator's reaction to the spirits he encounters. When he sees a ghost in his friend's room, a room adjacent to his own, he wonders how the apparition could have entered the chamber without first walking through his own room. It would seem that once one accepts the existence of ghosts, one could accept their passage through the walls or floors. However, the ordinary world has been expanded to include ghosts rather than abandoned entirely, and therefore the rules and categories of existence are not suspended. Thus the reader is struck by the incongruity of characters who take up daggers and revolvers to defend themselves against ghosts. Even the location of the house, stated in the very first sentence of the story, lends a sense of the normal and impending—this haunted house is in the center of London, in the heart of a busy city, rather than in a distant, enchanted forest or on some howling mountain peak.

When the narrator spends his first night in the house, he is most impressed by the power of the superior will he encounters; neither the phantoms nor the bizarre changes in the room affect him as do the sheer immensity of this force and his utter inadequacy to oppose it, which he likens to the way one feels in a storm at sea, in a fire, or near a terrible beast. Realizing that the house has been haunted by a living person, the narrator desperately seeks to know "to what extent human will in certain temperaments can extend," "to what extent thought can extend." Mr. Richards replies, in one of the most important lines in the story, "You

may write down a thought which, sooner or later, may alter the whole condition of China. What is a law but a thought? Therefore thought is infinite. Therefore thought has power; not in proportion to its value–a bad thought may make a bad law as potent as a good thought can make a good one" (p. 316). Potency, not morality, is most awesome, most worthy of admiration. Mr. Richards relates a fondness for old letters and manuscripts to the power and persistence of the written word. The Gothic attraction to old houses, to inheritance, and to all relics from the past is a symptom of this quest for endurance. The haunted house in this story is furnished with a mixture of old and new furniture, all time being duly represented. The manuscript in the drawer has preserved the thoughts that once filled the house, and these thoughts, in the form of apparitions, continue to haunt the building. The narrator forcefully proclaims, "thought is imperishable."

The emphasis on the everlasting, on length, is mirrored again in this story by clusters of long, unusual words: "evidently unsubstantial, impalpable simulacre, phantasms" (pp. 300-301), or "loftiness of punctilious curiosity" (p. 315), and extension in depth is pursued through the telescoping of narration-within-narration (for example, the author quoting the narrator quoting his friend quoting the housekeeper quoting the friend). Intensity is maintained through extreme contrast, for instance: "There was something incongruous, grotesque, yet fearful in the contrast between the elaborate finery, the courtly precision of that old-fashioned garb with its ruffles and lace and buckles, and the corpse-like aspect and ghose-like stillness of the flitting wearer" (p. 300). A constant contrast between physical emptiness and spiritual habitation in the haunted house functions as the contrast between silence and speech does in *Melmoth the Wanderer*. Words indicating concentration, "intense malignity in an intense will" (p. 317) or "horror to a

degree that no words can convey" (p. 298), recur incessantly, and an intensity of movement is evoked by the image of the Gothic line in spiderwebs, in bold and restless spirits, or in Mr. Richards himself: "a mighty serpent transformed into man, preserving in the human lineaments the old serpent type" (p. 310).

If we draw a comparison between the Gothic line and the Gothic hero-villain, we will see a certain maniacal egocentricity common to both. In this story Bulwer-Lytton describes the occult person as one who possesses to an astonishing degree the ability to concentrate thought on a single object—"the energic faculty that we call WILL" (p. 318). He is depicted as an absolute egotist, his will concentrated in himself, a man of fierce passions with a strong love of life who wants his desires fulfilled instantly, committing fearful crimes when challenged or thwarted. He has a rare knowledge of natural secrets and is a minute calculator whose faculties are sharpened by a love of self that replaces any love of truth. In *The Duality of Human Existence,* David Bakan terms "agentic knowledge" the type of learning associated with the enhancement of the ego and mastery of the world as opposed to "communion knowledge," which entails understanding another person or experience in the fullness of being. As the narrator in "The Haunters and the Haunted" explains, the occult figure would be miserable if he had affections; "he has none but for himself!" (p. 319). The contorted Gothic line can also be described as agentic in that it does not commune with other lines—it does not join with them or complement (in reversal) their form or rhythm. Rather, the line is heedless of other lines, crossing and recrossing them at will in a frantic tangle of movement and energy. Bakan links agentic knowledge with the demonic, pointing out that the word *demon* itself is derived from the Greek word for knowledge.[3] The demonic dissociation of agency and communion ultimately leads to

destruction, both of the other and of the self. Gothicism is very much the study of the unmitigated agency that wreaks destruction, promoting a return to primordial chaos.

Mr. Richards, the human agent in the story who haunts the house and mesmerizes the narrator, is, like Melmoth the Wanderer and Uncle Silas, typical of the classic Gothic hero of extended powers. He is a superman who can defy time by living on from generation to generation, he has a mastery of the secrets of science, and he can create startling changes in inanimate objects and human beings. He is a wandering stranger, "a wild, daring, restless spirit," an "outlaw," a "traveler," a "renegade," and a "parvenu," with fascinating "serpent eyes" and a peculiar, "satanlike odor." He has fled his country on the charge of a double murder within his own house, yet he has "a dignity akin to that which invests some prince of the East." He performs miracles and inspires visions; he has a rank near royalty, a certain "loftiness" about him; and he dies and comes back to life, having last been seen in the caves of Petra; miniature portraits of him are even made, and he is a patron of the arts. Calm and subdued in spirit, he will one day return in glory to rule the earth. Once again the composite Christ-Cain, demonic serpent, Faustian wizard is projected.

The mystical vision that the narrator experiences is one that embraces all time, that includes a superhuman figure, and that releases him from bodily limitations. "The vision that sees through the past and cleaves through the veil of the future is in you at this hour"–"The vision ... of a strong man with a vigorous brain." "As I spoke, I felt as if I rose out of myself upon eagle wings. All the weight seemed gone from air, roofless the room, roofless the dome of space. I was not in the body–where I knew not; but aloft over time, over earth" (p. 320). The mystical encounter here is not one of phantoms but of freedom. It is no wonder that when the narrator awakens and follows Mr. Richards, he finds a

message pertaining to his own death; the expansion he has experienced is beyond life, beckoning from the realm of death.

As in most Gothic works, death is the essential theme and motif in "The Haunters and the Haunted," permeating the story through the images of graves, coffins, and tombs, extinguished flames, whiteness, and bleeding. The story ends with a letter from Mr. Richards containing his promise to visit the narrator's grave a year and a day after his death, which causes the reader to speculate about the aftermath of death, its abyss, its finality, its eternity and mystery. The themes of the story are uniformly deadly; as labeled within the story itself, they are: "life in death and death in life" (p. 320), "the accidents which bring death upon the young," the "power to rouse up and revive the thoughts of the dead" (p. 317), and the ability to "stay the progress of death" (p. 319). Mr. Richards is able to defy death temporarily through the strength of his will and his love of life; a year ages him only as an hour would other men. Life and death are not divided but inserted within each other.

Mr. Richards presents the narrator with a cosmic scene of death. "In the north . . . there a specter will seize you. 'Tis Death!' " A haunted ship strewn with moldy bodies passes between mountains of ice beneath two moons and an iron sky red with meteors. Only one man is alive on ship, namely Mr. Richards, who can no longer prevail in this "death-spreading region." As the ice rocks close in upon the ship to "imbed it as amber imbeds a straw," Mr. Richards leaps from the ship and clambers up the spikes of ice as grizzled bears swarm after him. "On that day every moment shall seem to you longer than the centuries through which you have passed" (p. 322).

In this cataclysmic scene of death is echoed the final judgment portrayed in *Melmoth the Wanderer*. Melmoth too scrambles above an ocean of death to a mountain peak from

where he can view the dead and dying. For Melmoth time stands still for a moment, wedged between past and future, and the clock in the sky equates minutes with centuries just as hours equal years here. Despite the delay, death triumphs over the Melmoths and Mr. Richardses of the Gothic world.

Both "The Haunters and the Haunted" and *Uncle Silas* revolve around a house haunted by the murder of a child and the legacy of inheritance. In both cases the death of the victim results from a fall (in *Uncle Silas* from an upper story window and in "The Haunters and the Haunted" from a wall), and the theme of a fall is also involved in Mr. Richards's and Melmoth's mountain climb and their plummet into the sea of death. Uncle Silas has also fallen from wealth and status to poverty and depravity, and in "The Haunters and the Haunted" an heiress sinks lower and lower until she drops into the workhouse, reverses of various kinds having befallen her. Similarly, both the haunted house and Bartram-Haugh have fallen into a state of decline, and still other images of descent include the trap door in "The Haunters and the Haunted." The images in *Melmoth the Wanderer, Uncle Silas,* and "The Haunters and the Haunted" connote a fall from grace into sin, from heaven into hell, and from life into death, while Satan, the traditional fallen angel, is associated with Melmoth, Uncle Silas, and Mr. Richards.

In the novels of both Maturin and LeFanu, womb images of small rooms with tiny openings imprison their victims, trapping them and finally expelling them into death. In "The Haunters and the Haunted" such a room with two locked doors contains a dead dog, and another small, dreary cubicle without furniture has only one small window with closed shutters and no door other than its entrance. The window has been boarded up, as was that infamous window of death in *Uncle Silas,* and the absence of living beings is emphasized. The womb image has become a tomb.

The image of the serpent is associated with shadows in "The Haunters and the Haunted." The narrator states, "I turned my sight from the shadow, above all from those strange serpent-eyes that had now become distinctly visible. For there, though in naught else around me, I was aware that there was a will, a will of intense, creative, working evil, which might crush down my own." The vision of serpent eyes that the narrator sees in the haunted house appears when the moon's shadow is partially penetrated, and the dim shadow, described as the shadow of a shade, soon gives way to a hand holding a letter followed by swarming globules of colored light and finally by a woman in white. A male phantom presents itself, and just as it approaches the female, the shadow darts from the wall and wraps the figures in darkness. A last phantom of swarming larvae emerges before all things are again swallowed up by the dark shadow "as if out of that darkness all had come, into that darkness all returned" (p. 301). Jung links the image of the shadow with the snake when he states, "The snake, like the devil in Christian theology, represents the shadow ... the principle of evil" and with the narrow door, "The shadow is a tight passage, a narrow door, whose painful constriction no one is spared who goes down to the deep well."[4] Into shadowy, uncertain, chaotic waters sails the Gothic ship.

The culminating vision in the story is one of primordial, swarming creation. First serpent eyes grow from the shadow, then bubbles of light arise in an irregular, turbulent maze mingled with moonlight, and from the globules, as from the shell of an egg, hatch monstrous creatures: "The air grew filled with them; larvae so bloodless and so hideous that I can in no way describe them except to remind the reader of the swarming life which the solar microscope brings before his eyes in a drop of water–things transparent, supple, agile, chasing each other, devouring each

other–forms like naught ever beheld by the naked eye. As the shapes are without symmetry, so their movements were without order" (pp. 300-301). Life and its origins are depicted here as monstrous, cannibalistic, evil, and threatening. The Gothic message is that darkness and chaos are the root of reality, the source of life, and the fate of the future. During the narrator's exposure to this vision of life, his dog dies and his watch breaks. Although the most skilled watchmakers later attempt to fix the watch, it can never be repaired; it runs in a strange, unpredictable way for a few hours, and then comes to a dead stop. The precision and order of time is rendered erratic when confronted with the chaos of life. This basic image of chaos is also implicit in Mr. Richards's specter of death in the north and his almond of Damascus, which echo the biblical Jeremiah's vision in which evil and destruction also come from the north. (Jeremiah too sees an almond rod.) Beneath the story line, Bulwer-Lytton's images conjure up an apocalyptic vision of evil in which a serpent tempts man with forbidden knowledge resulting in death and a fall from grace. When the narrator persists in opening the ominous door to the haunted house and the secret powers of its haunter, he confronts the shadowy secret of his own fears. In the face of these secrets, the order man has created is worthless. The source of life and its destiny are horror and chaos.

NOTES

1. The story was printed under both names.

2. Edward Bulwer-Lytton, "The Haunters and the Haunted" or "The House and the Brain" in *Blackwood's Magazine* (1859), reprinted in Herbert A. Wise and Phylis Fraser, eds., *Great Tales of Terror and the Supernatural* (New York: Random House, 1944), pp. 295-96.

3. David Bakan, *The Duality of Human Existence* (Boston: The Beacon Press, 1966), pp. 60-61.

4. Carl Jung, *The Archetypes and the Collective Unconscious* (Princeton, N.J.: Princeton University Press, 1968), p. 322.

[7]
Frankenstein
by Mary Wollstonecraft Shelley
and *On the Night of the Seventh Moon*
by Victoria Holt

ON the surface these two novels would seem an unlikely choice for comparison–over a hundred and fifty years separate their publication dates (*Frankenstein* appearing in 1818 and *On the Night of the Seventh Moon* in 1972), and *Frankenstein,* though replete with the coincidences and improbabilities of Romanticism, approximates a science-fiction account of the creation of a monster while *On the Night of the Seventh Moon* is a love story about a young girl and a count, which seems factually realistic though sentimental. Dissimilar as they are, these two works share psychological biases, themes, images, and symbols that mark them as close Gothic relatives. Among those propensities already discussed in connection with the other works, we see again the Gothic line, particularly in the characters' complex, intersecting lives converging from different directions, but also in imagery and scenery, elongation in forms and word choice, irregularity in setting and behavior, persistent contrast, narration within narration in *Franken-stein,* intensity and extremity, an exposition of repressed material, and the descendental insertion of the super-natural within the natural. Notable are the compound

images of the heroes or villains, Frankenstein's monster being at once the new Adam and the Devil: "I ought to be thy Adam, but I am rather the fallen angel"; [1] he is called a "daemon" (p. 21) and a "satan" (p. 125), yet he is cited as dwelling near a place named Archangel. A Cain-like murderer who wanders, the monster is a stranger to mankind and a God-like superman of superior intelligence, sensitivity, height, power, and agility. Maximilian in *On the Night of the Seventh Moon* is likened to a number of mythical figures, and even Hildegard is termed both "some prophet of evil"[2] and "a guardian angel" (p. 249). The main characters in both these novels struggle with madness, Helena in *On the Night of the Seventh Moon* because she can neither dismiss nor verify experiences in her past that seem too vivid to have been imaginary, and the monster in *Frankenstein* because he can not recover or disregard the six years of his life that separate him from his mysterious origin. Helena is told that a man she loved and married and a child she bore are but dreams that she should forget, and the monster is likewise driven to distraction by the notion that his past is but a dream. Both characters are obsessed by their pasts and by their fear of insanity; both are bold, impulsive, fluctuating, excitable, and unbalanced; each is "the slave, not the master of an impulse" (Shelley, p. 218), "high spirited" (Holt, p. 17), and plagued by an "excess of agitation," an "excess of bodily exertion" (Shelley, pp. 195 and 132). A young, beautiful maiden and a grotesque monster are both ruled by wild, unreasoning love and violent longings.

With reference to violence, these two novels give a piercing, nuanced presentation of the sources and degrees of aggression ranging from more benign, life-affirming manifestations to malignant, destructive outbursts.[3] Frau Graben in *On the Night of the Seventh Moon* represents the mildest, most innocuous form of violence, the least drastic

and lethal, a type of playful violence that springs from curiosity, as when a cat plays with a mouse, or that energizes competition in athletic games. She amuses herself by caging insects together and watching them fight, often staging little contests for her bewildered friends, who nonetheless find her excitement infectious. Aunt Caroline, a rigid, destructive woman, exhibits a more reactive type of violence, born of frustration and disappointment, that is a defense of life, property, and freedom or a psychological response to the threat of denial or abuse. Caroline envies her brother's education, her sister's husband, her niece's youth, and everyone's health; in the name of her own discouraged potential, she critically attacks others to condemn or destroy their happiness. Duchess Wilhelmina, in a far more extreme expression of defensive violence, is driven to murder for her husband and kingdom, and Count Frederic becomes a sadistic killer out of envy of Maximilian. In *Frankenstein* the monster becomes violent only when his life and love are thwarted, the drama of his development tracing a progression from reactive violence to revengeful violence to compensatory violence. In revengeful violence the victim magically seeks to undo the wrongs he has suffered, as when the monster retaliates against his beloved peasant family after they reject him or when Frankenstein attacks the monster for his lost love. Although no less dangerous, this agression is still essentially biophilous ("life-loving" in Fromm's terminology) in that, however ineffective in reality, it seeks to restore life and recover beauty; it is a protest against violation. Compensatory violence is a substitute for creativity, a revenge on life for the negation of productive activity and thus a response to impotence. In the face of reduced self-control, it is a way to manipulate others through humiliation, torture, or enslavement, the victim finally being rendered inanimate in the drive for total domination.

Even bloodthirstiness, the regressive, archaic urge to kill, may spring as much from an affirmation of life as from a love of death in that blood is shed in a cannibalistic attempt to sustain the self, as depicted in the hunt or the ritualistic slaughter of the deer at the athletic events in *On the Night of the Seventh Moon*. Blood may be sacrificially poured upon the earth in the hope of insuring fertility. Whether or not such violence actually protects or retrieves life, life and death in intent and result are here intertwined.

Not to be confused with these violent eruptions are more pathological, death-oriented obsessions, such as necrophilia, literally the love of death, which involves a fascination with the inorganic, with corpses, feces, and dirt. Frankenstein's study of human decay or his description of the monster in terms of filth and human waste suggests a necrophilic fixation, as does Aunt Matilda's preoccupation with sickness and burials in *On the Night of the Seven Moon*. Matilda is attracted to disease, in herself and others, and eventually marries a frail man who has lost one of his kidneys. Helena speculates, "I wonder ... whether she would have fallen in love with Albert Clees if he had not been deprived of a kidney" (p. 146). Obsessive cleanliness may be symptomatic of necrophilic tendencies in that it is devoted to the sanitary absence of life. Both Matilda and Caroline abhor the vague untidiness that Helena finds "homey," preferring spotless, orderly, metallic regularity, a home that is "shining like a new pin" (p. 40). A related fondness for stones and rocks as symbols of the nonliving also persists in *Frankenstein* and *On the Night of the Seventh Moon*, as in so many Gothic novels. A direct attraction to death is evident in Holt's description of the Island of Graves, with its tombs, crypts, and coffins, in the figure of the ferryman (the messenger of death who, like Charon, rows people back and forth to

the island), in the many murders in Shelley's novel, and in Frankenstein's shocking dreams of kissing Elizabeth while she turns into the corpse of his mother with grave worms crawling in her nightgown.

Necrophiles tend to dwell in the past rather than in the future, and both *Frankenstein* and *On the Night of the Seventh Moon* deal with the search for past origins, Holt's novel even evoking a reversion to pagan celebrations. Both novels begin with a return to the past: in *On the Night of the Seventh Moon* Helena looks back on the adventures of her youth, and *Frankenstein* opens with a letter retelling episodes that have ended. The past is over; it is fixed; it can no longer be changed. Like a rock it is stable, dead.

The necrophile is enamored of force, dividing the world into the powerful and the powerless, the villains and the victims, the killers and the killed—that is, into the traditional Gothic dichotomy. The necrophile is drawn to darkness, caves, or the depths of the sea, to the frozen white oceans we see in *Frankenstein* in which even vegetation is absent. The necrophilic attraction may be compounded by narcissism, an all-encompassing love of self and a rejection of all that is not self. The concept of the stranger, the outsider, becomes dominant in the narcissistic framework, as illustrated in the character of Aunt Caroline, who is suspicious of the unfamiliar and denounces all that is foreign. "Outlandish was a favorite word of hers to be applied to anything of which she did not approve" (p. 46). The narcissistic perspective is reflected in Caroline's practiced self-righteousness undergirded by her conviction that people are motivated solely by self-serving intentions. "Aunt Caroline saw everything in that way. People did things for what they got, never for any other reason. I think she had come to look after my father to make sure of her place in heaven" (p. 41). Matilda's hypochondria is another form of narcissism in which concern with the self takes a negative expression. The more

irregular was Matilda's health, the more pleased she became. "She could also be quite happy discussing other people's ailments and brightened at the mention of them; but nothing pleased her so much as her own" (p. 41). The aunts are narcissistic in their inordinate emphasis on all that is homemade and are predictably self-absorbed to the point that they cannot relate to others; they never listen to each other, speaking independently rather than in conversation. Narcissistic inflation, the brand of self-absorption and aggrandizement apparent in all Gothic villains, is evident in Frankenstein's initial drive to master science to the point of omnipotence, to the point where he could become God in the act of creating a man—in fact, a man superior to the one that God created. The extremes of self-involvement are rooted in infant and prenatal stages and may therefore entail an incestuous inability to break primary ties, such as the ties to home and mother, to a native land, or to mother earth. A person who is incestuously fixated ultimately seeks a return to the darkness of the womb or, reaching further back, to earlier forms of animal life and inorganic compounds. A craving for certainty, predictability, and control are related to this fixation. In *On the Night of the Seventh Moon* Anthony exemplifies incestuous tendencies in proposing to a woman because his mother loves her (Helena makes the additional comment: "If Anthony had found a girl in the mist, he would have taken her straight back to where she belonged and if he could not, to his mother" [p. 44]); Count Frederic is incestuously tied to a substitute mother, the nurse who raised him whom he is unable to oppose even when she berates him like a child; and Frankenstein marries a woman whom he thinks of as his sister and who, in his dreams, is transformed into his dead mother.

When necrophilic, narcissistic, and incestuous tendencies combine, a frightening syndrome of violence and decay results, as can be seen particularly in the character of

Frederic, a man consumed by his concern for himself and his ability to dominate others; lacking all compassion even for his own children, he finally becomes a killer driven to completely possess people and power. In his final scene he stands on the island of graves, greedily peering into an open pit at the child he believes he has murdered.

Shelley and Holt systematically explore the different kinds and degrees of violent motivation in two works that are all but case studies in the pathology of violence and the attraction to death. Against this presentation of corrosive malignancy shine the exceptional, exuberant portraits, such as that of Helena Trant, the protagonist in Holt's novel, who describes herself as "in love with life," whose budding sexuality blooms with Maximilian—even Helena's wedding dress is organic green rather than white. In confrontation with violence, Helena intensifies her affirmations: "I can still recall that terrifying day on the Island of Graves where I looked straight into the face of death and learned then how precious life was" (p. 383). In *Frankenstein* the countervailing attraction to life is depicted, though not so unambiguously in a single character, in the navigator's impatience and ardent curiosity which, like Helena's, are sufficient to conquer all fear of danger or death. Like Maximilian, Frederic, and Helena in Holt's novel, Shelley's navigator (who is the narrator) ran wild for the first fourteen years of his life, and he is a sensitive day-dreamer who, like Frankenstein, is a lover of nature, especially spring. He is an inquisitive, anxious explorer eager for sensation. "I felt my flesh tingle with excess sensitiveness and my pulse beat rapidly. I was unable to remain for a single instant in the same place" (p. 56). This mixture or proximity of life-giving and death-oriented inclinations in these two novels, as in other Gothic works, is more striking and more horrible because combined. As Fromm states in reference to mental illness, sadism and masochism or necrophagia

and coprophagia are not perversions simply because they deviate from customary standards of sexual practice but precisely because they signify the one fundamental perversion: the blending of life and death.[4] Herein lies the essence of the Gothic perversion, a perversion that is inevitable in light of Gothicism's abhorrence of separations, whether between the sacred and profane, the beautiful and the ugly, the natural and the supernatural, or the healthy and the sick. The great Gothic compounds, relished for their intensity, are perverse as opposed to pure, giving a pungent, sweet-and-sour flavor.

Violence is the propellant that moves Gothic novels; the character is a stranger; the setting is a mountain; the secret is of origins and outcomes—a press toward the death on either side of life, the hereafter and the herebefore. The strangers in these two novels include Helena, who in England is regarded as foreign because her parents are German, while in Germany she is considered British; Ilse and Ernst, who are similarly strangers in both England and Denkendorf; Frau Graben, described as a stranger, who commends Helena for "taking in the stranger within her gates"; and, of course, both Frankenstein and his monster. The domestic and the foreign are clearly divided, as are indoors and outdoors, in both works; against Frankenstein's early domesticity and that of the aunts in England are set the fantastic adventures that follow. The exotic, the outcast, the outlandish (literally "another land") is characteristic of the other whom one becomes through loss—loss of native land, loss of past, loss of innocence—and the internal gap that results, the void filled by guilt, the changed sense of self, precipitates a greater self-consciousness and self-knowledge that separate the stranger first from his old self and then from the rest of humanity. A certain complexity that invites inspection, that leads to still other complications, beckons the stranger to unravel the mysteries; hence

Helena "wanders away from others" (p. 18), Frankenstein is the "divine wanderer" (p. 24), and the monster "wanders with wild agitation" (p. 101) through the countryside and into the past.

Helena comments:

> it is a strange feeling to know that a part of your life is wrapped in mystery and that you have been unconscious of what happened to you during that period. You feel apart from your fellow human beings. You are both a stranger among them and to yourself. (P. 111)

The unconscious past ultimately involves the question of origins: Frankenstein explores the source of life by creating a person himself, the monster searches for the secret of his own creation, and Helena discovers the birth of her child in her own forgotten past.

The terrain in these two novels, as in a great many others, is marked by peaks and overhanging precipices, icy cliffs, and misty summits where deception and disguise are promoted by haze. Whether the Alps, the Apennines, or the Orkneys, the ridges along the Arve, the Rhone, or the Rhine, mountains with their twisted paths become an extension of the hero's wanderings. Frankenstein climbs above the jutting rocks and ravines, temporarily at peace in his heavenly perch like a God who has transcended the contortions of life. From the mountaintop he can absorb the greatest vision of the world, a view that is astonishing, magnificent, sublime; he feels exalted, "elevated from all littleness of feeling" (p. 91). The monster too climbs skyward in the course of his wandering. "The desert mountains and dreary glaciers are my refuge. I have wandered here many days; the caves of ice, which I only do not fear, are a dwelling for me" (p. 95). Other heights—high latitude in the North, the height of the summer, the raising of spirits, the high of intoxication or enthusiasm, high destiny or the

higher powers of intellect, the sexual heights that Helena experiences after mounting the stairs to her lover's chamber, or the "high tea" drunk on the night of the seventh moon, which is in fact the time when the moon rises to its greatest height–all these elevations, along with the literal mountains, represent intensity of sensation and expansion of vision, inflation of the self and ascension to omnipotence. Mountains, according to Helena, are both beautiful and cruel, cruel because they are, in Frankenstein's words, "not in harmony with man"; a fall is inevitable. In *On the Night of the Seventh Moon* Helena dreams of a golden-haired child in a flowing white dress dancing along a narrow cliff while a guardian angel protects her. Helena herself leaves home to wander in the hills in search of her past, abandoning the safe road, and Frankenstein pursues the heights of curiosity and ambition. The monster observes a young girl who slips from a river bank into the rapid current, in *On the Night of the Seventh Moon* a pregnant girl throws herself from the attic of an inn, another pregnant girl (Girda) jumps down the mountainside from the window of a turret room, and there are two attempts to push Helena out of upper story windows. Emotionally, a rise in expectation is typically followed by sudden disappointment and the collapse of hope, and thematically a decline in status, wealth, health, or happiness echoes the biblical Fall from grace that is evoked through images of Adam's apple and the expulsion from Paradise. Whether literal or figurative, trivial or cosmic, a radical shift from ectasy to dejection–augmentation followed by drastic reduction–is the Gothic progression.

Frankenstein and *On the Night of the Seventh Moon* both leave the reader with a final image of ice, of glaciers, northern breezes, and snowy forests. The navigator's ship in *Frankenstein* becomes wedged in on all sides by a frozen sea most reminiscent of the one in "The Haunters and the

Haunted," where time slows down as in *Melmoth the Wanderer*. These "everlasting ices of the North," the "eternal frosts," represent not only an affinity for death but the secret of life as well; the navigator is searching for the wondrous power that attracts the needle at the point where life has been frozen still, arrested from its changes so that is can be observed. Like Frankenstein, who tried to discover the secret of all life, the navigator seeks to approach and fix the magnetic source of attraction.

The Gothic hell is not a fiery pit, not a burning pain or an all-consuming fear, but a stagnanat, rigid reality where the fluid and dynamic become concrete and secure. Gothicism abhors a fixed consciousness, security, stability, solidarity. In *On the Night of the Seventh Moon* Helena contrasts the shifting sands of romantic dreams with the house built on the firm rock of reality, and although she realizes that strong passions can destroy that house, she chooses risk and romance rather than Anthony's rock, rejecting religion and reason, repression and restraint, in favor of turbulent waters.

Through boundless curiosity or boundless seas, through excesses of despair or insatiable appetite, unremitting suffering, infinite wretchedness, gigantic stature, or inordinate strength, Gothicism aspires to enlarge the faculties, to exceed nature in all dimensions, in potency and duration. In *On the Night of the Seventh Moon* Ilse paraphrases Hamlet's famous lines: "There are more things twixt heaven and earth than are dreamed of in your philosophy." Gothicism encourages expansive dreams. Helena explains, "I had strayed into a strange world where events which would seem inconceivable in a logical world had happened." Gothicism strays into unfathomable worlds. An uncontrollable hunger for sensation and excitement, adventure, discovery, domination, and depravity is the germ that carries the Gothic infection. In the garden of the vicarage in

England, Helena notices on the sundial the old adage, so contrary to her own experience, "I count only the sunny hours." Gothicism cherishes the cloudy with the sunny, the bleak beside the brilliant; Gothicism counts them all.

NOTES

1. Mary Shelley, *Frankenstein: or The Modern Prometheus* (New York: Holt, Rinehart, and Winston, Inc., 1963), p. 95.

2. Victoria Holt, *On the Night of the Seventh Moon* (Greenwich, Conn.: Fawcett Publications, Inc., 1972), p. 72.

3. Eric Fromm, in his work *The Heart of Man, Its Genius for Good and Evil* (New York: Harper and Row, 1964), presents a theoretical and clinical discussion of the different degrees of violent inclination.

4. Ibid., p. 46.

[8]
Conclusion

LOOKING back over the landscape of Gothicism, we see a consistent pattern of thought reflected in particular propensities and convictions both within individual works and within the greater literary and artistic genre. Expansion and intensification are the essence of the Gothic experience, effected by a combination of the natural and supernatural into a continuous, immanent realm in which absolute separations between physical and spiritual or holy and profane are violated in order to create a single, greater domain. The scope of reality is further expanded spatially both within and without, within the tinest of delicate divisions-within-divisions and toward enlargements of size, height, and distance. Psychologically, this double expansion produces the simultaneous investigation of inner complexities and a supernatural grandeur beyond human life, while temporally, it reaches toward the past and the future, toward archaic memories, ancestral remains, and even an original formlessness, and toward the future destruction of death and a chaotic disintegration of order. Gothicism pursues the infinite in all its manifestations. The limitless, the incredible, the incomprehensible constitute the ultimate Gothic ideal, defying all restrictive tendencies, be they

moral, sexual, psychological, social, or aesthetic. Such compulsive expansionism runs the risk of anarchy, yet Gothicism confronts even the danger of formlessness as the consequence of expansion. Because death is the ultimate loss of form, the final anomic situation, Gothicism is drawn to death as well as life in its drive for inclusiveness.

The Gothic pursuit of intensification is a correlative to its drive for expansion; expansion is addition over area while intensification is addition within an area. Intensification of both reality and perception is crucial to the Gothic sensibility. Such amplification is created by the actual increase in the volume of reality, by the portrayal of extreme conditions, as well as by a perceptual illusion of intensity sustained by sharp contrast and the juxtaposition of extremes. Pain and fear are essential as both a cause and a symptom of intensification.

The value of intensity leads Gothicism to an admiration for absolute power and to a preference for power over beauty. An attraction to the surge of unchecked, explosive energy, to wild compulsion or restless dis-ease, entails an appetite for tyranny, sadism, and sickness. In its rejection of moderation, regularity, compromise, simplicity, and stability, Gothicism embraces the erratic, the complex, the convoluted, the excessive, the abnormal. It stresses the themes of eccentricity and madness and the forms of elongation and distortion.

The principles of expansion and intensification underlie each of the elements that characterize the Gothic literary genre, whether in the surface paraphernalia, the treatment of altered mental states, the appearance of ruins, the emphasis on the grotesque, the depiction of pain, torture, terror, and horror, the presence of the supernatural, the concern with insanity and with psychology in general, the attitudes toward ghosts and toward religion, the interest in sexual perversion, the attraction to disorder and revolution,

or the inclusion of Oriental sources. The same principle of expansion is at the heart of Gothic art, be it in the precursor of Gothic architecture, the Northern ornament, or in the fully developed Gothic cathedral. The line in this art, as in the literature, dramatizes the Gothic sensibility in its restless energy, its twisted agony, and its convoluted, asymmetrical course. Gothic art states in a visual way, through its use of unvaried repetition, dematerializing effects, and the juxtaposition of extremes, the same urgent message proclaimed in Gothic literature.

Finally, within individual Gothic tales expansion and intensification are apparent in the author's choice of setting, characters, plot patterns, and imagery, where certain common configurations predominate. Twisted forms, elongation, unvaried repetition, asymmetry, irregularity, juxtaposed extremes, telescopic circumscription of forms within forms, and multileveled application of layer upon layer recur from work to work, contributing to the sense of a greater, limitless reality, just as they do in the hallmarks of the Gothic literary genre and the components of Gothic art.

A number of common themes in Gothic tales also echo the drive for inclusiveness and for the proximity of contrasting extremes, most particularly the combined God-devil images, where, in the context of greater power, absolute good and evil are wed; the merger of strong necrophilous and biophilous tendencies; the image of the Fall (as well as the mountain, from which a fall occurs, and the Garden, in which the biblical Fall from grace took place), where the polarities of height and depth, success and failure, salvation and damnation are immediately juxtaposed; and the contrasting images of solidity and fluidity, of rock (or ice) and water, where a contrast of life and death, organic and inorganic, or womb and tomb are emphasized. In order to project the greatest incorporation, Gothicism includes all that is generally excluded; it reveals the shadow

and the stranger, exploring their immanence within this life and within the self. Gothicism exposes the feminine within the masculine, the anima within the animus, either symbolically or through direct homosexual allusions, and highlights the hidden strength within the apparent weakness (the courageous moral fortitude within the frail heroine) or the weakness within strength (the seemingly invincible villain who is finally destroyed). The narrow path and the tiny passageway followed by an open expanse are among the pervasive archetypal images in Gothic literature, which signify the difficult road to greater self-knowledge or a greater perception of life and also suggest the expansion of a birth experience, often blended thematically with an image of death and an absence of definition.

The Gothic imagination soars to the heights and penetrates the depths. It broaches the unthinkable, attempts the forbidden, and assaults the ordinary with terror and with zest. The other side of that creaking door is the other side of the self. Gothicism is an invitation to peer into the darkness that precedes and follows the light, the great expanse of unknown surrounding an island of life. The chill of eternity incites a rush of activity; we run toward and away from our fear.

Bibliography

Abercrombie, Lascelles. *Romanticism.* London: Martin Secter, 1926.

Addison, Agnes. *Romanticism and the Gothic Revival.* New York: Gordian Press, Inc., 1967.

Aubert, Marcel. *The Art of the High Gothic Era.* Translated by Holle Verlag. New York: Crown Publishers, Inc., 1965.

Bakan, David. *The Duality of Human Existence.* Boston: The Beacon Press, 1966.

Barzun, Jacques. *Classic, Romantic, and Modern.* Boston: Little, Brown, and Company, 1961.

Birkhead, Edith. *The Tale of Terror: A Study of the Gothic Romance.* New York: E. P. Dutton and Company, 1920.

Blackwood, Algernon. "The Camp of the Dog," in *John Silence, Physician Extraordinary.* New York: Donald C. Vaughan Publisher, 1915.

Blatty, William Peter. *The Exorcist.* New York: Harper and Row, 1971.

Bloom, Harold. *The Ringers in the Tower.* Chicago: University of Chicago Press, 1971.

Brontë, Emily. *Wuthering Heights.* 12th reprint ed. New York: Holt, Rinehart, and Winston, 1962.

Bulwer-Lytton, Edward. "The Haunters and the Haunted" or "The House and the Brain." in *Great Tales of Terror and the Supernatural,* edited by Herbert A. Wise and Phyllis Fraser. New York: Random House, Inc., 1944.

[147]

Campbell, Joseph. *The Hero with a Thousand Faces*. Princeton, N.J.: Princeton University Press, 1971.

Clark, Kenneth. *The Gothic Revival*. New York: Scribners, 1950.

Cram, Ralph Adams. *The Gothic Quest*. New York: Doubleday, Page, and Company, 1918.

Dinesen, Isak, ed. *Seven Gothic Tales*. New York: Random House, Inc., 1961.

Edinger, Edward F. *Ego and Archetype*. Baltimore, Md.: Penguin Books, 1973.

Fenichel, Otto. *The Psychoanalytic Theory of Neurosis*. New York: W. W. Norton and Company, 1945.

Ferenczi, Sandor. *Problems and Methods of Psychoanalysis*. vol. 3. New York: Basic Books, 1950.

——. *Sex in Psychoanalysis*. vol. 1. New York: Basic Books, 1950.

Feuerbach, Ludwig. "The Truth of Religion," from *The Essence of Christianity*. London, 1854. Reprinted in Norman Birnbaum and Gertrude Lenzer, eds., *Sociology and Religion: A Book of Readings*. Englewood Cliffs, N.J.: Prentice-Hall, Inc., 1969.

Frankl, Paul. *Gothic Architecture*. Baltimore, Md.: Penguin Books, 1962.

Freud, Sigmund. *Beyond the Pleasure Principle*. Translated by James Strachey. New York: Bantam Books, 1962.

——. "The Uncanny," in *The Complete Psychological Works of Sigmund Freud*. vol. 2. Translated by James Strachey. London: The Hogarth Press and the Institute of Psychoanalysis, 1955.

——. *Three Essays on Sexuality*, in the *Complete Psychological Works of Sigmund Freud*. vol. 2. Translated by James Strachey. London: Hogarth Press and the Institute of Psychoanalysis, 1957

——. *Totem and Taboo*. Translated by James Strachey. New York: W. W. Norton and Company, 1961.

Fromm, Erich. *The Heart of Man: Its Genius for Good and Evil*. New York: Harper and Row, 1964.

Godwin, William. *Caleb Williams*. New York: Holt, Rinehart, and Winston, 1967.

Hallie, Philip. *The Paradox of Cruelty*. Middletown, Conn.: Wesleyan University Press, 1969.

Hauser, Arnold. *The Social History of Art*. New York: Alfred A. Knopf, Inc., 1951.

Holt, Victoria. *On the Night of the Seventh Moon*. Greenwich, Conn.: Fawcett Publications, Inc., 1972.

Hugo, Victor. *Oliver Cromwell*. Philadelphia: George Barrie and Son, 1896.

Jung, Carl Gustave. *The Archetypes and the Collective Unconscious*. Princeton, N.J.: Princeton University Press, 1969.

Kayser, Wolfgang. *The Grotesque in Art and Literature*. Translated by Ulrich Weisstein. Bloomington: Indiana University Press, 1963.

LeFanu, J. S. *Uncle Silas*. London: Macmillan and Co., Ltd., 1899; New York: Dover Publications, Inc., 1966.

Levin, Ira. *Rosemary's Baby*. New York: Random House, Inc., 1968.

Lewis, Mathew. *The Monk*. New York: Grove Press, 1952.

Lewis, W. S., ed. *Horace Walpole's Correspondence*. New Haven, Conn.: Yale University Press, 1937.

Lucas, F. L. *The Decline and Fall of the Romantic Ideal*. Cambridge: Cambridge University Press, 1963.

Lunblad, Jane. *Nathaniel Hawthorn and the Tradition of Gothic Romance*. Cambridge, Mass.: Harvard University Press, 1946.

McDougall, William. *Outline of Abnormal Psychology*. New York: Charles Scribner's Sons, 1961.

McKillop, A. D. "Mrs. Radcliff on the Supernatural in Poetry." *Journal of English and Germanic Philology* 31 (1932).

Male, Emile. *The Gothic Image*. New York: Harper and Row. 1968.

Martindale, Andrew. *Gothic Art*. New York: Frederick A. Praeger Publishers, 1967.

Maturin, Charles Robert. *Melmoth the Wanderer*. 3 vols. London: Richard Bentley and Son, 1892.

Moore, Charles Herbert. *The Development and Character of Gothic Architecture*. New York: Macmillan and Company, 1890.

Munro, Thomas. *The Arts and Their Interrelations.* New York: Liberal Arts Press, 1951.

Panofsky, Erwin. *Gothic Architecture and Scholasticism.* New York: Meridian Books, 1960.

Parker, John Henry. *An Introduction to Gothic Architecture.* London: James Parker and Company, 1906.

Pater, William. "Romanticism." *Macmillan's Magazine* (London) 35 (1876-77).

Penzoldt, Peter. *The Supernatural in Fiction.* London: Peter Nevill, Ltd., 1952.

Poe, Edgar Allan. *Selected Prose and Poetry.* New York: Holt, Rinehart, and Winston, 1950.

Propp, V. *Morphology of the Folktale.* Translated by Laurence Scott. Austin: University of Texas Press, 1968.

Radcliffe, Ann. *Gaston de Blondeville.* Philadelphia: H. C. Carey and I. Lea, 1826.

——. *The Mysteries of Udolpho.* Edited by Andrew Wright. New York: Holt, Rinehart, and Winston, Inc., 1963.

Rawcliffe, D. H. *Illusions and Delusions of the Supernatural and the Occult: The Psychology of the Occult.* New York: Dover Publications, 1959.

Read, Herbert. *Art and Society.* 1937; reprint ed. New York: Shoken Books, 1970.

——. *The Meaning of Art.* London: Faber and Faber, Ltd., 1951.

Sadleir, Michael. "The Northanger Novels: A Footnote to Jane Austin." *The English Association Pamphlet,* no. 68. Oxford: The University Press, November, 1927.

Scarborough, Dorothy. *The Supernatural in Modern English Fiction.* New York: G. P. Putnam's Sons, 1917.

Scholes, Robert. *Structuralism in Literature.* New Haven, Conn.: Yale University Press, 1974.

Shelley, Mary. *Frankenstein: or the Modern Prometheus.* New York: E. P. Dutton and Company, Inc., 1951, The Bobbs-Merrill Company, Inc., 1974.

Shumaker, Wayne. *Literature and the Irrational.* Englewood Cliffs, N.J.: Prentice-Hall, Inc., 1960.

Stoker, Bram. *Dracula.* Garden City, N.Y.: Doubleday and Company, Inc., 1959.

Summers, Montague. *The Gothic Quest: A History of the Gothic Novel.* London: The Fortune Press, 1938.

——. *The History of Witchcraft and Demonology.* New York: Alfred A. Knopf, Inc., 1926.

Thorpe, Louise P.; Katz, Barney; and Lewis, Robert T. *The Psychology of Abnormal Behavior: A Dynamic Approach.* New York: Ronald Press Company, 1961.

Todorov, Tzvetan. *The Fantastic: A Structual Approach to a Literary Genre.* Cleveland, Ohio: Case Western Reserve University Press, 1973.

Varma, Devendra P. *The Gothic Flame.* London: Arthur Baker, Ltd. and Morrison and Gibb, Ltd., 1957.

Walpole, Horace. *The Castle of Otranto.* London: G. P. Putnam and Sons, Ltd., 1972.

Worringer, Wilhelm. *Form in Gothic.* London: G. P. Putnam and Sons, Ltd., 1972.

——. *Form Problems of the Gothic.* New York: G. E. Strechert and Company, 1912.

Index

DATE DUE			
OCT 10 '94			
MAR 25 '96			
MAY 06 '96			
APR 2 1 1997			
MAY 0 1 2001			
DEC 1 0 2001			
APR 08 2009			